IMAGES
of America

HUNTINGTON

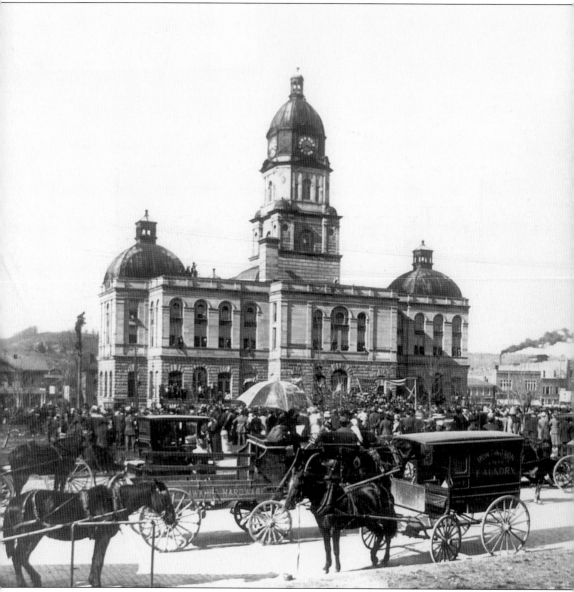

CABELL COUNTY COURTHOUSE. President Theodore Roosevelt appeared at the Cabell County Courthouse in October of 1904, campaigning in Huntington against Henry G. Davis, who was on the Democratic ticket and from West Virginia. On November 8, 1904, Roosevelt defeated the Democrats in the election. The view of the courthouse is on the Fifth Avenue side; notice to the left in the picture that a series of Queen Anne homes once existed on Fourth Avenue.

IMAGES
of America

HUNTINGTON

Don Daniel McMillian

ARCADIA

Images of America: Huntington *is dedicated to Eleanor L. Ferguson McMillian,
the author's mother, whose unfailing belief and constant assurance
through the years has helped make this book a reality.*

CONTENTS

Acknowledgments 6

Introduction 7

1. The Huntington and Emmons Families 9

2. The Gilded Age, Social World, and Good Life 15

3. Early Prominent Families 19

4. Old Central City 49

5. Historic Churches 55

6. Historic City of Huntington 61

4. Huntington's Historic Homes and Public Buildings 95

ACKNOWLEDGMENTS

Images of America: Huntington speaks of a rich cultural history that rose from the ashes of the Civil War to create its own "Gilded Age" of opulence and stunning architecture. It is a historic architectural review of the exceptional homes, both past and present, and the early families who contributed to the development of the city.

This publication involved over five years of research by the author and the cooperation of many individuals and families. Many of the photographs are from the author's own collection, while others required the kind assistance and professional services of Ed Wright, Special Collections of the James E. Morrow Library, Marshall University; Mr. Huey Perry and Mr. Wilburn Bias of Bias Blueprint; The First Congregational Church; Mr. Lake Polan III; Ms. Liza Caldwell; Mr. William R. Ritter; Mr. Charles Lloyd Ritter III and Mr. John T. Ritter; The Masonic Temple Association; .Mr. and Mrs. Phillips Emmons; Mrs. Earleen Heiner Agee; Dr. Constance Hayden; the late Frederick Mestel; Mr. Edwin N. Vinson; WSAZ Channel 3 and their photo collection; the Cabell County Public Library, Special Collections, Archival records; Mr. William Cammack Campbell; Mr. Randal Brown's Special Collections; Mr. Donald L. Lord, Computer Technician; Professor Carlos Bozzoli, architect, and visiting professor The Drenko Academy, Marshall University; Jeffery Todd Darst; Gaddy Engineering Company; the American Institute of Architects; Mrs. Nina M. Johnson, archivist and historian, The National Trust for Historic Preservation; The Library of Congress; Special Collections, the West Virginia Division of Culture and History; former and present members of the American Institute of Architects; the late J.B. Stewart; Verus T. Ritter; Edwin N. Alger; Harry Rus Warne; William B. Frampton; Gunn & Cutiss; H. Zigler Deitz; C.H. Hancock & Sons; Wilbur T. Mills; Dean, Dean & Tucker; the Robert and Sidney Day family; Meanor & Handloser; and the former Sadler Tile & Stone Company.

INTRODUCTION

The Gilded Age following the close of the Civil War was the "Age of Innocence," when ignorance was bliss. From 1870 to 1915 there was a period of great financial and industrial activity. The United States had started floating loans to Europe, which brought us in contact with the great financial houses of Europe and, in turn, gave rise to the house of Morgan and brought about the Jay Cooke failure in 1873. Perhaps the greatest phenomenon of this era was the expansion of our railway systems. The great trans-continental railroads were built and huge fortunes were made—and lost—in stock operations and real estate speculation. Carnegie and Frick not only made possible the rails for the new railroads, they also laid the foundation for the world's greatest industrial corporation. The Gilded Age was a period that had little time for the acquisition of culture; however, with the possession of money came a growing avidity for it. The royal way to culture and the arts was via the checkbook and the greenback.

Architectural styles that evolved were the Victorian Gothic and the French style of the Third Empire from the American invasions of Europe. England had been the pioneer in the preceding Classic Revival; what followed was the Gothic Revival style of Sir Charles Barry, the architect of the House of Parliament, whom the English regarded as the greatest architect since Sir Christopher Wren. What eventually came home to America was the work of Belcher and Norman Shaw, whose work was dubbed the "Queen Anne" style. In France, following the rise and fall of Napoleon III, was a brilliant period in French architecture. What followed from France was a contemporary Renaissance and the adaptation of the mansard roof and ornamentation. Another style of architecture and furniture design was Eastlake, evolving from the remarkable talent of Charles Locke Eastlake who was the first of Arts-and-Crafters. Eastlake was a contemporary of the Victorian Revival. America's adaptation to this exceptional style of architecture is apparent in the city of Huntington. The evolution of Huntington's Edwardian Age, from 1900 to 1915, is filled with a rich cultural influence. (To speak of the Edwardian Age we must first remember that Edward VII, King of England, known as the "Peacemaker," was born in 1841, and ruled until 1910. Edward VII and Queen Mary were the last and final Emperor and Empress of India.) Huntington is fortunate in its architectural history; its people contributed their expressions, wants, and sentiments of the period, and they have left us an exceptional treasure. The Edwardian Age is the accumulation of the designs and eclecticism that evolved from the Gilded Age from 1870 to 1915. Technology and the Industrial Revolution forever altered America's art, architecture, design, textiles, furniture, and lifestyles. As the Victorian Age settled into its closing days, many Americans embraced a new age and the dawn of "Electricity," bringing forth a new lifestyle filled with new creature comforts. Homes now glowed in the evening with Edison's light bulbs. The old coal furnaces and gaslights within the home were converted to electric. Soon many of the barons of lumber, coal, natural gas, and electricity began to build their stunning estates in the south hills of Huntington and on the new Fifth Avenue, which became a fashionable address. Huntington began installing streetlights and trolley cars that added a new dimension and awakened residents to evenings out on the town. Huntington totally embraced the Arts and Crafts Movement. Today some of the finest architectural achievements in the country are right within our midst, as you will discover in the following pages.

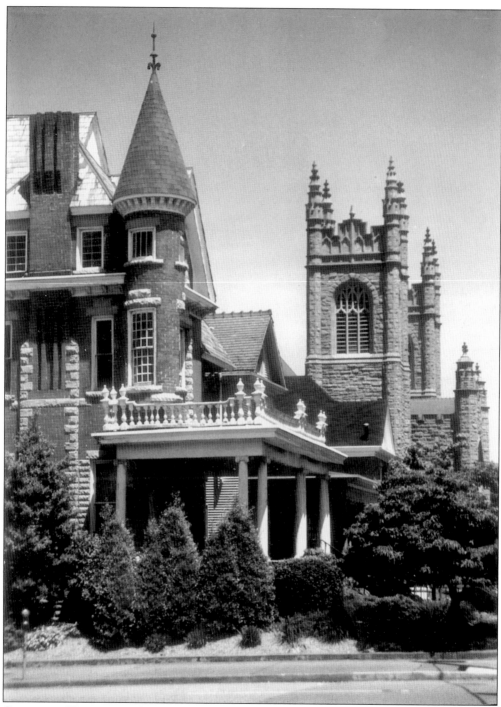

CAMPBELL HOME AND CHURCH. Architectural departments had begun to open in the American universities, and an increasing number of men and women were returning from Paris, London, and Rome after earning degrees in design and architecture. This new breed of architects, designers, and engineers were all active protagonists of the classical principles of design and architecture, as expressed by the classical structures above.

One

THE HUNTINGTON AND EMMONS FAMILIES

Before the arrival of Collis P. Huntington, founder of the city of Huntington, the State of Virginia Board of Public Works planned the construction of a railroad from Covington, Virginia, to the Ohio River to be known as the Covington & Ohio Railroad. Virginia started condemning land in September 1853 for its right of way. By 1861 some of the portions of its right of way were graded and the piers for the bridge over the Guyandotte River were begun; however, the work came to an end because of the Civil War and the burning of Guyandotte in 1861. At the close of the war the State of Virginia had been divided and the completion of the railroad had become a matter to be arranged by the states of West Virginia and Virginia. Each state, after considerable efforts and disputes, proposed the identical Act to Incorporate the Chesapeake & Ohio (C&O) Railroad Company. The acts passed by both states for undertaking the work, which was to be done in the name of the "Chesapeake & Ohio Railroad Company." This contract was duly made by both states on August 30, 1868.

Gen. William C. Wickman became president of the company and acquired the interest of Collis P. Huntington. On April 4, 1868, Cabell County citizens voted to take $150,000 in capital stock of the C&O Railroad. James H. Ferguson was named the agent of the county to subscribe for the stock. In 1869–1870, Delos W. Emmons, co-founder of the city of Huntington, and Albert Laidley made options for the land, farms, and former plantations along the Ohio River. Work on the C&O Railroad began on both ends of the proposed road, and in August of 1871, a locomotive wood burner named Greenbrier was brought down the Ohio River by boat and unloaded to begin construction of this end. On January 29, 1873, C.R. Mason drove the last spike, and the railroad was connected between Hawks Nest and Kanawha Falls.

Collis P. Huntington had developed an early interest in railroads in California, along with a few other investors, including Leland Stanford and Charles Crocker. These daring young men developed a small rail system, which evolved into a nationally recognized company for its Trans-Continental railway system. On May 10, 1869, the final golden spike was driven in Promontory, Utah; this great moment connected, for the first time, the continental United States from the Atlantic to the Pacific Ocean.

Huntington left New York on June 23, 1869; he went to Washington, D.C. and then to White Sulphur Springs, West Virginia. He, along with Delos W. Emmons, came with General Wickman and H.D. Whitcomb, chief engineer of the new railway, to inspect the proposed location on the Ohio River. Traveling by boat down the New River to Hawks Nest, Huntington's arrival into his future city was by horseback. What greeted him in the Ohio Valley was the expansive flat land along the Ohio River. Huntington stayed at the Carroll Hotel on Guyan Street in Guyandotte. From here he explored the new city of Huntington. It was from the Carroll Hotel that he instructed Albert Laidley to make preparation to purchase all available land along the Ohio River just west of the town of Guyandotte.

The staggering feat of Virginia to build a railroad from the Chesapeake Bay to the Ohio River had been completely shattered by the deadly War Between the States and the tragic Reconstruction period that followed. Between 1864 and 1869, Virginia's railroads lay in total ruin and staggering debt had piled up on the former crown colony, while another state, West Virginia, was extrapolated from Virginia's old Mid-Atlantic dominion. Still, Huntington's astute mind and business acumen did not fail to see the profound advantages of the opening of virgin lands and the unlimited source of virgin timber, coal, minerals, and natural gas. Later, Collis P. Huntington became a guest of Peter Cline Buffington and his family at Pleasant View, on Staunton Road.

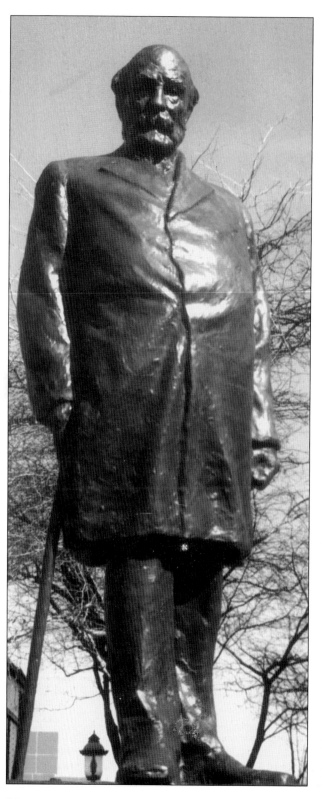

COLLIS P. HUNTINGTON. The bronze sculpture of Collis P. Huntington was created by Gutzon Borglum, artist of Mount Rushmore. Mrs. Arabella Huntington, second wife of Collis P. Huntington, donated the bronze sculpture to the City of Huntington on October 23, 1924. Seven thousand local citizens and dignitaries greeted Mrs. Mary Parsons Schrewberry, a grand niece of Collis P. Huntington and a resident of the city, as she removed the canvas revealing the extraordinary gift. Mrs. Arabella Huntington had died six weeks before, leaving her husband's $150,000,000 endowment, known as the Huntington Trust.

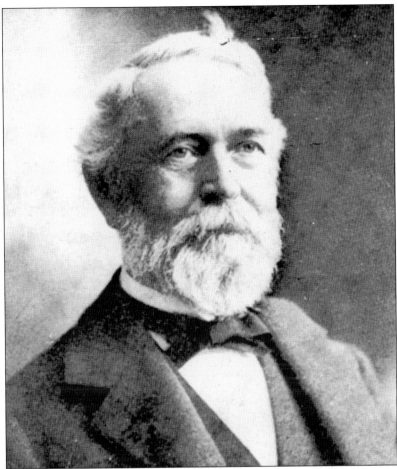

Delos W. Emmons, Co-Founder of the City of Huntington. On February 6, 1870, Mr. Emmons wrote to Collis P. Huntington, advising him to abandon the proposed purchase of land at the mouth of the Big Sandy, which had long been known as Virginia Point, and urged the selection of land on the west side of the Guyandotte River. Emmons secured options under nearly all the former farms and plantations between Guyandotte and the mouth of Four Pole Creek. After the options were secured, Emmons told Huntington what he had done. On Tuesday, February 22, 1870, Emmons received a letter from Huntington approving his selection and a draft of $50,000 was received to close and secure the options. The draft prepared by the Central Land Company in New York complicated Emmons's efforts in closing the land deal. Portsmouth, Ohio, was the nearest place to convert the note into cash. Scotia County in Ohio had already suffered through previous land speculators from New York and the rampant production of counterfeit Union currency flowing out of Adams County, Ohio, and—Mr. Emmons being a stranger to all bankers—$50,000 in currency was a large sum to rise and entrust to a stranger having a sight draft. One banker, Mr. Dugan, liked Emmons and informed the other bankers that he would give Emmons all he had and be responsible for the difference. The currency was secured in Portsmouth, packed in several grip bags, and put aboard the passenger boat, which was completely delayed for two hours in order to get the funds together. While making temporary headquarters in Charleston, Emmons met and employed Gen. John Oley, who was appointed agent and who greatly assisted in forming and installing the plans for the new city of Huntington. General Oley was loved and admired by the Emmons family; at the time of Oley's death he was a guest at Pleasant View Manor.

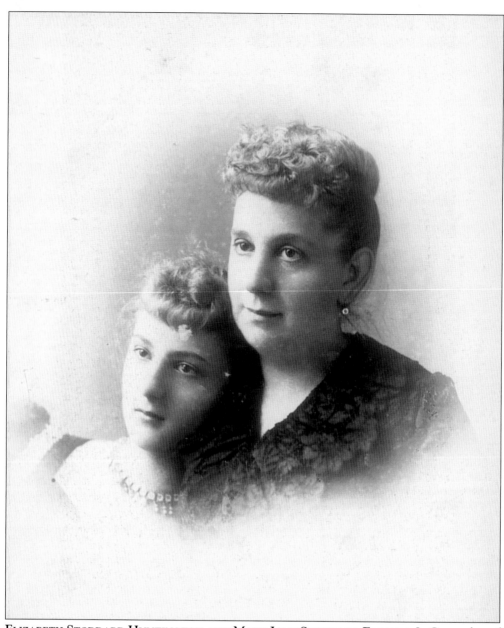

ELIZABETH STODDARD HUNTINGTON AND MARY JANE STODDARD EMMONS. In September of 1844, Collis Huntington married Elizabeth Stoddard of Litchfield County, Connecticut. Elizabeth was a member of a well-established, patrician family of Connecticut. She moved with her new husband from Oneonta, New York, to Sacramento, California. Her younger sister Mary Jane Stoddard married Delos W. Emmons on October 30, 1851. The Stoddard family had first come to America in 1639 and settled in Boston. The old home of the Rev. Anthony Stoddard, which was built in 1702, still stands near Woodbury, Connecticut. The old house was long a palisade fort used for the protection against Native Americans, and it is now one of the historical showplaces of Connecticut. Anthony Stoddard's son Norman graduated from Harvard in 1662, one of the 18 descendants of the Stoddard family to graduate from Harvard University by 1828.

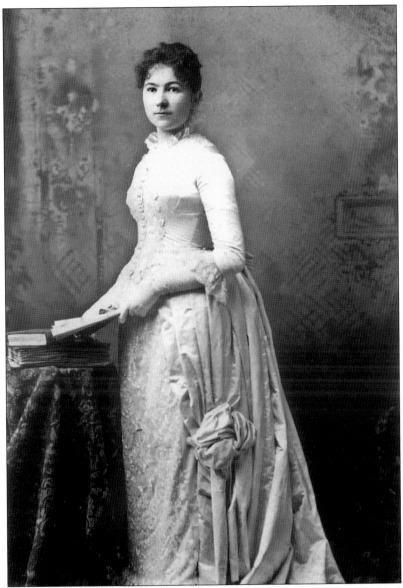

MARY JANE STODDARD EMMONS ON HER WEDDING DAY, OCTOBER 30, 1851. Mary Jane was the daughter of William Stoddard, a woolen manufacturer whose ancestors had established the first woolen mills in what is now the United States. Born in West Cornwall, Connecticut, and educated in the state of New York, she became known for her hospitality. Five children were born to Delos and Mary Jane: four sons and one daughter. Sons Arthur S., Collis, and Carleton D. and daughter Elizabeth were all citizens of Huntington in 1916. The fourth son, J. Alden, died in 1915. Mary Jane was one of the pioneer mothers of the city. In 1871 when news of the enterprising town called Huntington on the Ohio River reached Mary Jane through her sister, it was decided to move the entire family here. The Emmons family arrived in Huntington by boat. Mary Jane called Pleasant View home for over 45 years. She died on July 26, 1916, only a few weeks shy of her 85th birthday. The funeral took place at Pleasant View. Today her remains lay in repose beside her husband at the Emmons Mausoleum in Spring Hill Cemetery in Huntington.

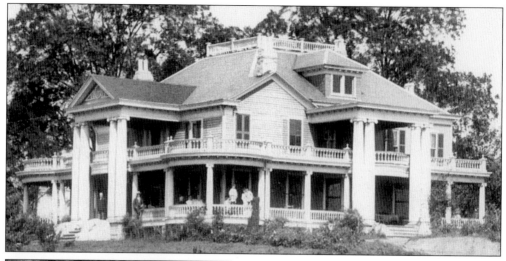

PLEASANT VIEW MANOR. Once located on Staunton Road and Thirty-first Street East in Huntington was the former Thomas Buffington plantation; in 1870, the home became the official residence of the Emmons family, who renamed it Pleasant View. Added to the former home were the two-story, Ionic columns that support the extended porticos on the south and east entrance, as well as the elaborate two-story, spindled, Queen Anne verandah that wraps the structure. Col. Peter Cline Buffington shared his own home with Colonel Emmons and his family during the repairs and restoration to the residence. Pleasant View Manor was originally a 434-acre estate extending from the mouth of the Guyandotte River, west on the shore of the Ohio River to Twenty-second Street and Third Avenue. Delos W. Emmons sub-divided the plantation, keeping the part of the estate that extended from Third Avenue and Thirty-first Street to the Ohio River and west to Twenty-ninth Street and Third Avenue. Collis P. Huntington resided at Pleasant View when in Huntington. The brother-in-law of Collis P. Huntington, Emmons first came to Guyandotte in 1869 and was associated with the C&O Railroad Company. When the Central Land Company was organized, Mr. Emmons was its general superintendent and continued as such until 1888. Pleasant View Manor was demolished in August 2003. On the left, standing in the main entrance of the portico, is Collis P. Huntington.(Courtesy of Mr. and Mrs. Phillips Emmons, great-grandson of Delos W. Emmons.)

Two
THE GILDED AGE,
THE SOCIAL WORLD, AND
THE GOOD LIFE

Social life in Huntington from 1870 to the turn of the century was very different; entertaining in homes in the early days was done mostly because no other places were available. On Sundays, married couples always returned to their homes to be with their parents and extended family for dinner after church. Often, couples dined with the husband's parents on one Sunday and then with the wife's parents the next Sunday.

Receptions were really the most popular form of entertaining in the early years. Several hundred guests were invited to one of these brilliant affairs, given in a large club or in large homes. Music was provided by a string quartet, creating a pleasant background. Guests were served delicious food, punch, and coffee. Pleasant View Manor was often the center of social activities in the early days. The mansion was poised atop a knoll and surrounded by 20 acres of gardens for vegetables, lovely flowers, and manicured lawns extending to Third Avenue. There was a large barn for cattle and horses to the west of the home. Once a year the Emmons hosted the largest social affair of the season at their country estate. Whenever Mary Emmons went into town, her housekeeper Nannie, an important person in the household for 48 years, prepared gifts for friends in town and also food for the members of the Ladies Aide Society.

In 1872 John Hooe Russell moved to Huntington; he participated in early social activities and was involved in the "Irving Club," the earlier version of the Guyandot Club. His greatest achievement was the founding of the Gypsy Club in the 1880s. The Gypsy Club is one of Huntington's most distinguished clubs, celebrating over 120 years of existence. It was named after Mrs. Charles Ward of Huntington, formerly Miss Gypsy Fleming, the daughter of West Virginia governor A.B. Fleming. John Hooe Russell gave the first dance of the new "Gypsy Club" on May 1, 1889, at Mitchell's hall on Third Avenue. Chaperones were very much in evidence in 1889; those who were married though very young were eligible to officiate as chaperones for the other girls, many who were their own age. As years passed and elegant hotels were built the social standards began to change. Social balls, tea dances, and receptions were given at these new architectural palaces. By 1904 many of the receptions were held at the Guyandot Club, located on Fourth Avenue and Eleventh Street.

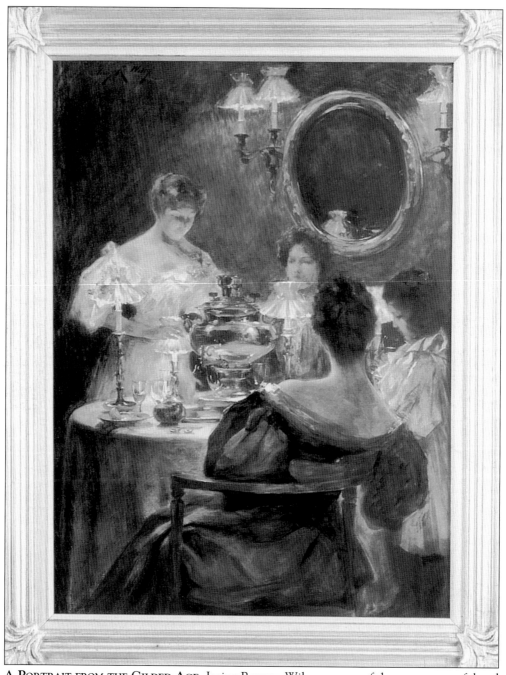

A PORTRAIT FROM THE GILDED AGE. Irving Ramsay Wiles was one of the most successful and admired portrait painters of the Gilded Age. (Painting by Irving Ramsay Wiles, Smithsonian Collection, Washington, D.C.)

FORMER MAIN ENTRANCE, PLEASANT VIEW MANOR. Delos Emmons left home on a daily basis to attend to business affairs; he would take a pound of butter, a dozen eggs, a basket of vegetables, and a large can of buttermilk, which he gave to sick friends and others he favored. Housekeeper Nannie's jelly, tarts, cheeses, and preserves were favorites, and in the winter, meats were delivered to relatives and friends. Pleasant View Manor was the scene of many beautiful social affairs. The home was once painted a beautiful pale yellow with white trim. Many Huntington families remember the Golden Anniversary party the Emmons gave for several hundred guests. A miniature gold bell with their marriage date engraved on it was given to each guest as a favor.

NATIONAL REGISTER OF HISTORIC PLACES, THE HARVEY-ENSLOW HOME, BUILT 1874.
Located at 1305 Third Avenue on the southwest corner of Twelfth Street East stands the
Harvey-Enslow home. This West Indies Caribbean–style plantation structure was built by the
Harvey brothers. William H. and his brother Thomas H. Harvey came to Huntington in 1869
from Buffalo, Putman County, West Virginia. The brothers started construction on this
architectural jewel in late 1873 and completed it in 1874. The home has survived a series of
owners, additions, and alterations with the principal front edifice remaining intact. The
windows and entrance are recessed in Palladian stone arches with stained glass fanlight
windows above. Directly above the central window are a stone engraved with 1874 and a
medallion roundel. Originally all the windows and doors had arched Caribbean shutters that
opened and closed. The pagoda-style roof is supported by a series of paired brackets that rest
upon fluted Ionic columns. The balustrade with the turned spindles trims the porch and the
principal structure sits on a one-story foundation that also once supported shutters flanking the
lower windows. The Harvey brothers operated their law firm and part-time residence together
before William Harvey moved to Gallipolis, Ohio, in 1876, married Anna Halliday, and then
moved to Cleveland, Ohio. William Harvey's nickname of William "Coin" Harvey came from
his publication in 1894 titled Coins Financial School. William Hope Harvey was a respected
economist whose theory of "free coinage" of silver was a proposed solution to the national
financial troubles in the turbulent 1890s—coined the "Cleveland Panic"—and represented the
collapse of the gold market on a global level while America was drowning in sterling silver.
William's solution was offered to no avail. The Harvey brothers were both involved in the
William Jennings Bryan Campaign of 1896 for the Democratic ticket for President against
Theodore Roosevelt. In 1895, Frank Bliss Enslow, regarded as one of the most influential men
of Huntington, purchased the Harvey home and lived in the structure while building on its east
side one of Huntington's most elaborate, 26-room, Jacobean and Queen Anne mansions. His
brother Edward Bliss Enslow's home stood on the west side of the Harvey home. Frank Bliss
Enslow's ornate mansion later became Steele Funeral Home; fire eventually destroyed it.

18

Three
EARLY PROMINENT FAMILIES

ANDREW JACKSON ENSLOW. Andrew J. Enslow was born in Richmond, Virginia in 1824. The Enslow family later moved to Wheelersburg, Ohio. In 1846 Andrew J. Enslow married Nancy Maria Bliss, who was born in 1828 and died in 1913. The Enslows had four sons and one daughter; one son died in infancy. At the request of Collis P. Huntington, Andrew J. Enslow came to Huntington in 1870. Enslow was a professional contractor and assisted in laying out the streets for the new city, using the finest red bricks made in America. Enslow was one of the first leaders of a newly formed board of education on February 27, 1871. The West Virginia Legislature passed an act incorporating the new City of Huntington, one of the first professionally planned cities in the United States. Enslow was appointed street commissioner. Within the first 25 years of the creation of Huntington, its council included Delos W. Emmons, Ely Ensign, Andrew J. Enslow, E.S. Holderby, J.H. Poage, Dr. E.T. Buffington, and Henry C. Simms. On June 19, 1871, Andrew J. Enslow and N.H. Pennybacker purchased two lots on Second Avenue and Seventh Street; they built and opened two stores.

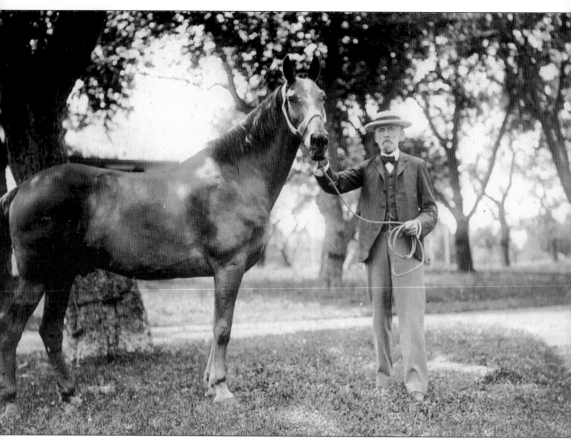

ANDREW JACKSON ENSLOW, SPENDTHRIFT FARMS, LEXINGTON, KENTUCKY. This rare photograph of Andrew J. Enslow was taken at Spendthrift Farms; he appears with his prize-winning horse in Lexington, Kentucky. The Combs family, owners of Spendthrift Farms, were relatives on the Bliss side of the Enslow family. Andrew J. Enslow was a guiding light in creating one of the first planned cities in the nation. He faced dirt roads that would turn into quagmires during storms and boardwalks used for sidewalks that would often shift in the storms; however, in a short time the Enslow name would become one of the most prominent in the city of Huntington.

FRANK BLISS ENSLOW. Frank was born in Wheelersburg, Ohio, in 1853 and came to Huntington at age 18. He worked for his father, Andrew J. Enslow, assisting in the stone and brick work for the C&O Railroad. One of Huntington's first police officers, Frank later participated in the formation of the Huntington Hospital. He taught himself law and was admitted to the bar in 1871. He formed the Triple State Gas Company and the Columbia Gas & Electric Company. Later, he became general counsel for the C&O Railroad and the Huntington Water Company. In 1881 Frank was appointed director and vice-president of the Bank of Huntington. In 1894 he was appointed vice-president of the Huntington National Bank; he became president in 1903. Frank established a telephone company that was later purchased by Southern Bell Telephone. Before his death in 1917, Frank was elected president of the West Virginia Board of Trade. His first wife was Julia Garland Buffington; they had one son, Frank Bliss Enslow Jr., who died in May of 1976. Before Julia died in 1897, Enslow had a daughter, Dorothy.

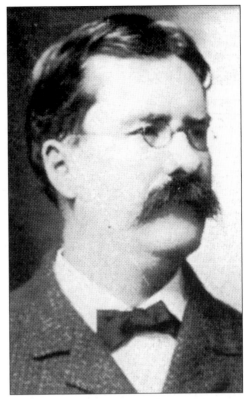

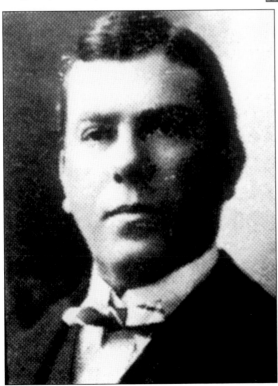

EDWARD BLISS ENSLOW. Edward Bliss Enslow was born in 1858; he was a member of several insurance firms for more than 20 years. In 1882 he bought the oldest insurance company in Huntington from Robert. T. Oney, and the firm became E.B. Enslow Insurance Company. Through a series of changes and business partnerships the company later became the Statts & McIntosh Insurance Company. Edward married Constance Kelly; their daughter, Catherine Bliss Enslow, was born February 14, 1899. Catherine became one of the prominent editors and society writers at the *Huntington Advertiser* for many years. Edward and Constance's home was located on the corner of Thirteenth Street and Third Avenue next to the historic Harvey home. Later the lavish Enslow mansion built by Frank Bliss Enslow was home to Catherine for a number of years.

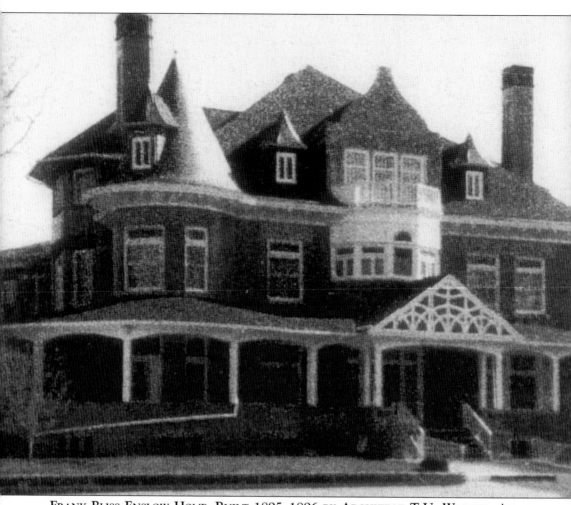

Frank Bliss Enslow Home, Built 1895–1896 by Architect T.U. Walter. Attorney Frank Bliss Enslow occupied his new palatial residence in May of 1896. The design of the structure, with its spacious piazza, balcony, bay windows, and port-cochere, is impressive. The interior was laid out with a view to unite convenience and elegance. On all sides of the structure there are interesting details, especially the bay windows and the tall and commanding chimneys, which are an architectural feature themselves. The building materials were among the best available and the construction of the most substantial character—the smallest detail was not overlooked. T.U. Walter of Huntington was the architect and deserves great credit for the handsome design, as do the builders, who made so perfect a finishing of the architect's conception and left such a splendid a monument to his skill. Entering the main floor from the imposing piazza or verandah, one is struck with the beauty of the large reception hall. The broad, low staircase of exquisite design and paneled divan are its principle features.

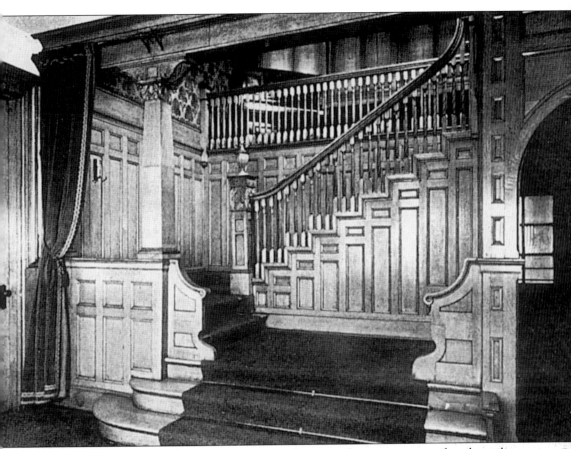

THE PALATIAL ENSLOW MANSION. The carved columns to the staircase extend to the ceiling, supported along a paneled frieze of quartered oak. The staircase and halls are lighted by a large bay window—starting from the gallery of the stairs and extending to the roof—and are glazed with delicately tinted stained glass. The hall has paneled wainscoting and a fireplace with tiled hearth, facing the mantel of quartered oak—carved and supported on long Corinthian columns. All of the principal rooms are seen from the hall through its many openings in almost its kaleidoscopic completeness. To hall's west is the library, spacious, well lighted, and finished in rare walnut, with a tripled mullioned window, bay shaped and filled with French plate glass and transoms of stained glass of special design. The fireplace has a carved walnut mantel with small cabinets on either side. To hall's east is the parlor, sitting room, and dining room. The parlor and sitting room are finished in high quality cherry and have elegantly carved mantels with onyx tile facing and hearths. The rooms are of massive proportions—the dining room being 20 feet wide by 30 feet long, one of the largest in the state. A large alcove at the farthest end of the room contains a stationary drinking fountain of imported onyx and space for buffet or sideboard. The low board fireplace has a mantel of quartered oak with a two-inch, beveled mirror and tiled onyx facing the hearth. The butler's pantry boasts imported pine and contains Italian marble sinks and a built-in refrigerator. The kitchen is trimmed and wainscoted with similar wood and marble. The second floor contains six bedrooms, all opening in the large upper hall. Each room is finished in a different kind of wood—quartered oak, cherry, maple, plain oak, and yellow pine. The principal bedroom has a large dressing room with private bath and toilet room attached, modern and elegant in all its appointments. In each bedroom is a stationary wash stand of Italian marble with large oval bowls. Bathrooms and toilet rooms have walls lined with imported tile and porcelain tile bathtubs and marble washstands.

CATHERINE BLISS ENSLOW. Catherine began working for the *Advertiser* newspaper in 1917 at 18 years old. She graduated from the new Huntington High School in 1917 and studied dancing in Chicago. She was an active Democrat, a county executive committee woman, and a delegate to the Democratic National Convention for two years. A member of the First Presbyterian Church of Huntington since 1914, she was also a member of Alpha Chi Omega sorority, a charter member of the Junior Woman's Club of Huntington and the Altrusa Club, and a Kentucky Colonel. During World War II she directed recreation for the aviation cadets stationed at Marshall College. She served as director of the American Woman's Voluntary Services on the USO Board during the war. Catherine's family included sister Alice Enslow Johnston of Huntington; niece Gloria Henderson of Columbus, Ohio; nephew John William Johnston of Huntington; and two great-nieces—Blissy Johnston and Sibyl Johnston Thompson. **SIBYL JOHNSTON.** Sibyl is a professional violinist who performs with the Huntington Symphony Orchestra.

ELY ENSIGN AND MARY WALTON ENSIGN, 1871. Ely Ensign was born in Litchfield, Connecticut, in 1840 and was a descendant of James Ensign, one of the founders of Hartford, Connecticut. Ely married Mary Caroline Walton (1848–1915) in 1869. The Ensigns came to Huntington, West Virginia, in 1871 to oversee the building for what would become the very successful Ensign Manufacturing Company, now ACF Industries. Organized in May of 1872, Ensign Manufacturing was established to build railroad car wheels and castings for the Chesapeake & Ohio Railway shops. Ely Ensign was only 30 years old when he arrived in Huntington. He took charge of the construction work for the company shops, and in 1882 the plant expanded production by building both freight and mine cars. Ely served as secretary-treasurer and manager until 1889, when the Ensign Manufacturing Company merged with American Car and Foundry. In 1893–1894, Huntington experienced a depression and the President of the United States forced the temporary closing of Ensign Manufacturing. To ease the burdens of unemployment, Ensign built a home at 1330 Third Avenue, giving his employees work. The home was to have the first electric lights in the city. Ely was elected mayor of Huntington in 1896 (against his own will) and was one of the best. He died in 1902 in his home, on Third Avenue. Mary Caroline Ensign and Ely Ensign's youngest daughter, Anna Clarinda Ensign, was born in 1880. Anna Ensign would later marry William F. Hite, a member of an old Virginia family, who worked as a telegraph operator and an agent for the Chesapeake & Ohio Railway. In 1897 William F. Hite would become mayor of Huntington. The Ensigns' second child, Mary Prentiss Ensign, died in 1889 at the age of 15. In 1906, their son, John Walton Ensign, became mayor of Huntington and served for two terms.

ANNA CLARINDA ENSIGN HITE. In 1902 Anna Ensign, daughter of Ely and Mary Ensign, married William F. Hite, a member one of the oldest families on this side of the Alleghenies. William was born in Guyandotte on September 3, 1867, the son of Frank and Mary Brammer Hite. William was 14 years old when he entered the C&O Railway System, and he quickly became freight agent for the C&O. He later worked for the Baltimore & Ohio in the same position. In 1897 he became the first Republican mayor in Huntington. In 1900, William became interested in the local investors who were acquiring eastern Kentucky coalfields, and he became secretary-treasurer for three major coal companies. In 1913 William Hite and Dave Gidion purchased the Huntington Herald Company and became the publisher of the *Herald Dispatch* until 1918, when William sold his interest to Dave Gidion. His affiliation with the railroad ended in 1913. He became a Republican candidate for the U.S. Senate in 1918; however, his opposition, Howard Sutherland, had 2,000 more votes. In 1920, William was a delegate to the Republican national convention that nominated Warren G. Harding for president. The Hite family led a gracious life until the morning of August 7, 1930, when the Hite sedan encountered a lumber truck at an intersection in Portsmouth, New Hampshire. The truck struck the rear of the Hite sedan with tremendous force, hurling the car into a tree and telephone post on the right side of the street. William, who was seated on the right side, was thrown partially through a window upon impact with the tree. He suffered internal injuries and died 30 minutes later. Anna was seriously injured. Carolyn and William Warner Jones, grandchildren of the Hites, and Linwood Coaton, the chauffeur, were not injured. William and Anna Hite had returned to Huntington earlier from their summer residence in Newcastle, New Hampshire, after having returned the remains of their daughter, Mary Hite Jones, 28, home for funeral and burial. The Hites also had a son, Francis Ely Hite.

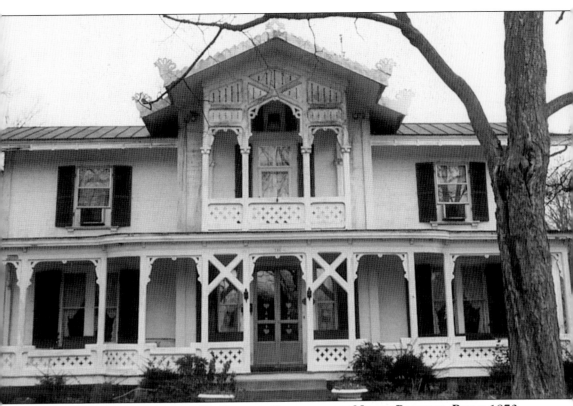

HISTORIC ST. CLOUD HOME OF H. CHESTER PARSONS AND NELLIE PARSONS, BUILT 1870.
Historic St. Cloud is the residential center of a former village featuring a series of late 19th-century, Victorian frame residences, built along Madison Avenue near Ninth Street West and extending to Jefferson Avenue. The St. Cloud subdivision was developed on lands adjacent to the home of Capt. H. Chester Parsons, a prominent figure in the development and settlement of the new city of Huntington. Located at 729 Ninth Street West, the Parsons, Abbott, Mosser residence is the oldest in St. Cloud district. This extraordinary romantic Carpenter Gothic Revival home, with its Victorian two and one half–story frame structure, features a front elevation of elaborate saw work, particularly in the two-story entrance bay verandah. Deep eaves, paneled fascia, and ornate wood-raking cornices and the wood trim highlight the tin roof. The horizontal, wood, flush siding is painted white and a cottage addition in the Second Empire style was attached in 1880. The house features original, ornate, Victorian, interior, hard wood finishes; the front door is exceptional for its high relief paneling. The home and the front lawn were the scenes of many parties for the executives of the C&O Railroad Company. When Collis P. Huntington was appointed president of the new C&O Railroad Company in 1869, he appointed Parsons as director. Parsons was born in St. Albans, Vermont, in 1840. He served in the Union Army as captain during the Civil War, was wounded at the Battle of Gettysburg, and later mustered out as a colonel in 1864. During the war, he met Nellie Loomis, a well-bred Southern belle from Fairfax County, Virginia. He returned to Virginia and married Nellie and started promoting the C&O Railroad and the coal and iron mines in Virginia and West Virginia. In 1870 Chester and Nellie moved to Cabell County, West Virginia, and built the impressive house on Ninth Street West. Parsons became the local attorney for the C&O Railroad and was on the first train into the new city of Huntington in January 1873. He became a founder, trustee, and treasurer of the First Congregational Church, located on Fifth Avenue and Ninth Street East. Many of the local citizens who built homes in the St. Cloud community were prominent figures in the development of Huntington's civic and business affairs.

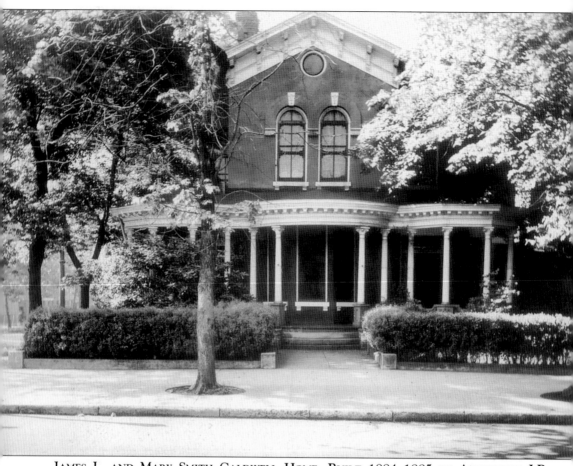

JAMES L. AND MARY SMITH CALDWELL HOME, BUILT 1884–1885 BY ARCHITECT J.B. STEWART. Once located on the corner Twelfth Street and Third Avenue, this Edwardian-style, Queen Anne structure with Jacobean details has a restrained elegance with stucco finish over brick. The graceful front verandah has a serpentine elliptical shape, trimmed in brackets in a dentil block fashion. A series of Ionic columns rest on a sandstone balustrade. The principle gable above is supported also by a series of elaborate brackets; resting below is a central roundel window. Set in stone is a pair of arched Palladian windows enclosed in a raised arch with decorative ornamentation. James Lewis Caldwell was born at Elizabeth, in what is now Wirt County, West Virginia, in 1846. He was the son of John T Caldwell, a native of Stubenville, Ohio, and Regina Burns Caldwell of Megs County, Ohio. In 1862, at the age of 17, he enlisted in Company F, Sixth Ohio Infantry, in which he served during the remainder of the Civil War. He was in General Grant's army and took part in several battles. Caldwell took residence in Guyandotte with his father-in-law, Nicholas Smith, and they both entered the mercantile business. Caldwell also engaged in the timber business. He prospered in these undertakings and when the new city of Huntington began to assume important business proportions, he took a leading part in activities. J.L. Caldwell lived in Guyandotte until 1884, when he moved to the fashionable section of Third Avenue and Twelfth Street. J.L. Caldwell, George Miller Jr., and other investors established the First National Bank, of which Caldwell was president until his death.

JAMES LEWIS CALDWELL AND THE GUYANDOTTE VALLEY RAILROAD COMPANY. James Lewis Caldwell was the first to see the profound possibilities of the coalfields of southern West Virginia and eastern Kentucky. In 1889, J.L. Caldwell secured a survey for the railway line to Pineville at the head of the Guyandotte Valley and offered this to the Norfolk & Western Railway. He came very close to getting this route adopted—he never gave up on his dream and after several years of both hard efforts and disappointment, he organized the Guyandotte Valley Railway Company. M.E. Ingalls, president of the C&O Railway, regarded the Guyandotte Valley as C&O territory, and in order to preserve it as such, he made terms with J.L. Caldwell. The name of the railroad was the "Guyandotte Valley Railway Company," and J.L. Caldwell was president for five years. The road was built to Midkiff in 1904, where disputes broke out over right-of-way. Later the road was extended to Buffalo, and J.L. and his associates built seven miles on Buffalo Creek and extended the road seven miles on Dingess Rum.

MARY O'BANNON SMITH CALDWELL. Mary Caldwell was the wife and widow of one of the most conspicuous figures in the financial and business life of the city of Huntington. Widely known and respected socially, she was a devoted homemaker and focused on the care of her husband and children. A member of the First Presbyterian Church, Mary Caldwell was a constant supporter of a number of local charities. She was born in Newcastle, Kentucky, on January 22, 1852. With her parents, Mr. and Mrs. Nicholas Smith, she moved to St. Albans, West Virginia. It was in St. Albans that she became the bride of Gen. J.L. Caldwell on May 8, 1871. For the first several months of their married life, she and her husband lived in Wheeling; they later moved to Guyandotte with her parents.

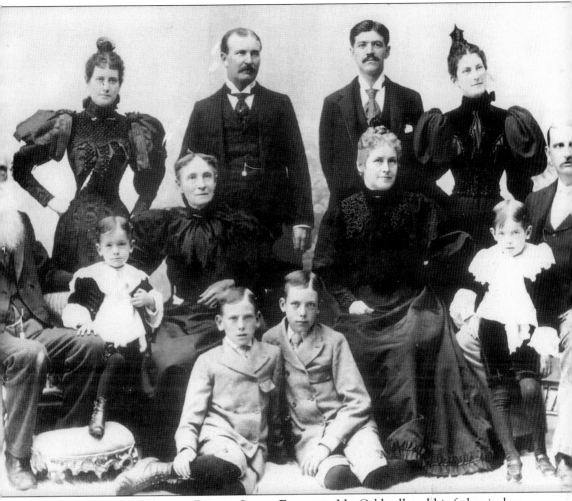

THE CALDWELL, McFADDEN, PRATT, SMITH FAMILIES. J.L. Caldwell and his father-in-law, Nicholas Smith, engaged in the hardware business in Guyandotte, later embarking in the timber business along and up the Guyandotte River. J.L. and Mary's two daughters, Ouida Caldwell and Ida Caldwell, were born in Guyandotte. These two young ladies evolved into extraordinary "social arbitrators" in their own right and enjoyed a lavish patrician existence. As Huntington grew and prospered, J.L. Caldwell acquired some financial interest in the young city. He had already commissioned the well-known and respected architect J.B. Stewart in 1884 to design his classical Edwardian Regency Queen Anne house on Third Avenue and Twelfth Street. For 17 years, Main Street in Guyandotte had been home; the new residence on Third Avenue would be home for Mrs. Caldwell and her family for the next 40 years. J.L. Caldwell was prominent in other business activities and was at the time of his death—on October 18, 1923—ranked the wealthiest citizen in the state. He and Mary were married for 52 years. Mrs. Caldwell left six children, nine grandchildren, and one great grandchild; her sons were Nicholas Smith Caldwell, James Lewis Caldwell Jr., George Jackson Caldwell, and Foree Danby Caldwell of Huntington. She was 76 years old when she died in 1927. In the photograph above from left to right are Ida Caldwell McFadden, W.P. McFadden, Bernard Pratt, Ouida Caldwell, Nicholas Smith, Liza Peter Foree Smith, Mary Caldwell, J.L. Caldwell, Nicholas Smith Caldwell, James Lewis Caldwell Jr., George Jackson Caldwell, and Foree Danby Caldwell.

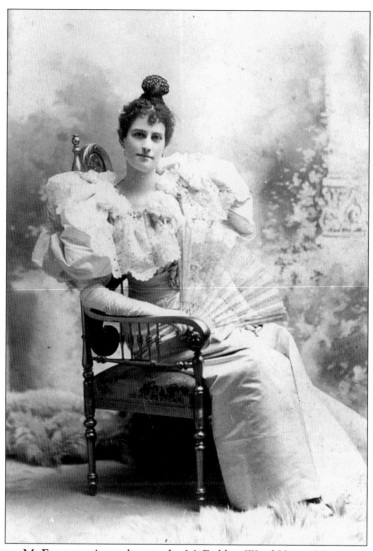

IDA CALDWELL MCFADDEN. According to the McFadden-Ward House Museum in Beaumont, Texas, W.P.H. McFadden was born in 1856 in Beaumont and died in 1935. A widower with three children, he came to Huntington in 1894 to marry Ida Caldwell (1872–1950), the daughter of J.L. and Mary Caldwell. Ida purchased her wedding attire in Cincinnati, Ohio; the gown was custom designed by her favorite dressmaker, Anna Dunley. The wedding was one of the major social events in Huntington in 1894. W.P. McFadden's business interest was in ranching, farming, real estate, and oil—interests that led him to considerable wealth for both his family and the city of Huntington. In 1896 the McFaddens were living in Beaumont in a house on Liberty Avenue when they built a fashionable Queen Anne–style house on Calder Avenue. Ida's fine taste was reflected in the new home. Near the end of 1906 the McFaddens traded that house for a new one built for W.P.H. McFadden's sister and brother-in-law, Di and C.C. Averill. The McFaddens and their three children, Mamie, Perry, and Caldwell, moved into the new Beaux-Arts Colonial–style house at 1906 McFadden Avenue. Ida established solid relationships with her stepchildren, who often referred to her as Stida or "Sister Ida." Ida's influence and intelligence positioned her as one of the hostesses of Beaumont society. Mamie, Perry, and Caldwell grew to adulthood in the house on McFadden Avenue.

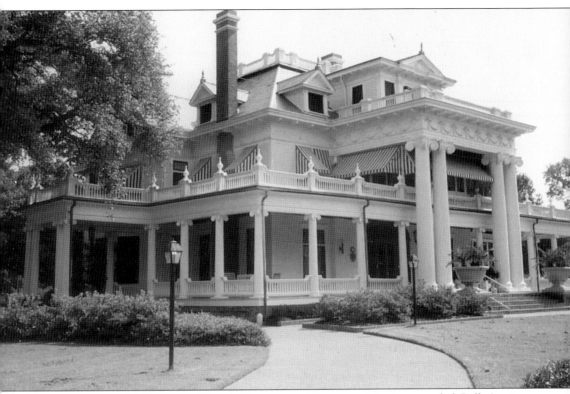

THE CALDWELL, McFADDEN, WARD HOME AND MUSEUM. Mamie attended Bell Austin Institute, a private grade school in Beaumont, before studying at Gunston Hall, a finishing school in Washington, D.C. She returned home in 1912 and settled into an active social life. In 1913 she started seeing Carroll Ward, who was from a prosperous business family in Beaumont. Mamie's parents were reticent and concerned about Carroll's wild reputation; nevertheless, Mamie and Carroll continued their love affair and on May 21, 1919, the couple married in the parlor of the McFadden home. Mamie and Carroll honeymooned in Cincinnati and Huntington and later returned to live with Mamie's parents in Beaumont. The young Mamie had established a place for herself and her husband in the McFadden household; her mother Ida turned over the operations of the home to Mamie. In raising her children, Ida McFadden often closed the Beaumont house in the summers and brought the family to Huntington to visit her relatives, and on occasions to the beach house at Caplen on the Bolivar Peninsula. Ida and Mamie both refused to live a life of idleness and upon the death of Ida's brothers, she became president and CEO of the J.L. Caldwell Company, which her father had founded in Huntington. In 1950 after several months of illness, Ida Regina Caldwell McFadden died; she was buried in the family plot at Magnolia Cemetery. In 1961 Carroll died, leaving Mamie alone in the McFadden home. They had remained childless throughout their marriage. Mamie died on October 24, 1982, just short of her 87th birthday, leaving in her will provisions for turning her home into a museum.

JENNIE RATLIFF CAMPBELL AND CHARLES WILLIAM CAMPBELL. Charles was born near Red Sulphur Springs in Monroe County, West Virginia, on September 29, 1856. The Campbells were early settlers in the Greenbrier Land Company in the 1780s. The son of Robert D. and Catherine Johnson Campbell, Charles attended Monroe County schools and read and studied law. In 1880, hearing that the Eastern Capital was becoming interested in the purchase of coal and timberlands in Lincoln and adjoining counties, he decided to go to Hamlin to reside and practice law. In April 1881 he was admitted to the bar. On August 28, 1888, he married Jennie Ratliff, the daughter of George F. and Nancy Frazier Ratliff. Early in 1888 he moved to Huntington and remained active until his retirement in 1924. His most notable professional service was his involvement in the King Suit. This suit started in 1892 and involved the title to most of the land in what is now Logan, Mingo, Wyoming, Boone, Lincoln, and part of Kanawha and Raleigh Counties. Campbell was instrumental in the development of the timber and coal resources of southern West Virginia. Charles and Jennie's children included Rolla Campbell, a graduate of Harvard University; Charles William Campbell, mayor of Huntington; Nan Campbell; Ruth Campbell; and Jennie Eloise Campbell. Charles William Campbell Sr. was instrumental in building the Logan Branch of the C&O Railway and also the 12 Pole line of the Norfolk & Western (N&W) Railway Company. In addition, he aided in the development of many of the feeder lines for the N&W Railway Company and the C&O Railway Company in Logan and Mingo Counties. His dearest outside interest was the First Presbyterian Church of Huntington. He served for many years as an elder. A Democrat, Charles became a follower of William Jennings Bryan. He was a member of the legislature in 1911, where he served as chairman of the judiciary committee and a member of the finance committee. Charles William Campbell's most notable political office was as mayor of Huntington (1919–1922). His administration was noted for its rigid enforcement of the city's finances, which he found in a deplorable state and which he left in splendid condition. The Campbells' home is located on the northeast corner of Fifth Avenue and Eleventh Street in Huntington.

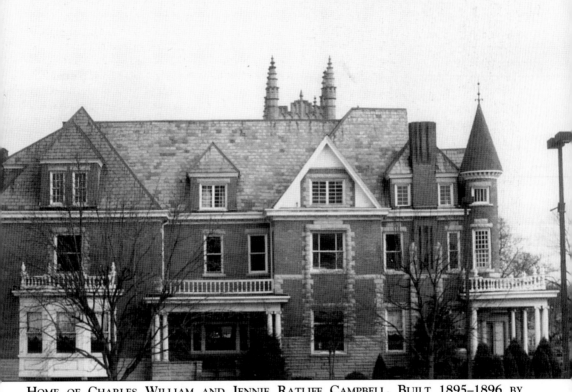

HOME OF CHARLES WILLIAM AND JENNIE RATLIFF CAMPBELL, BUILT 1895–1896 BY ARCHITECT J.B. STEWART, NATIONAL REGISTER OF HISTORIC PLACES. The Campbell residence is one of the most outstanding, nearly intact, four-story classical Queen Anne and Jacobean–style structures in West Virginia. There is exceptional masonry brick and elaborate rusticated sandstone detailing on the front elevation of the structure, dominated by a slender, two-story Queen Anne and Jacobean–detailed turret that is cantilevered out at the second-story level. The tower has two high, narrowed, elliptical windows and two smaller windows at the second level. These windows have heavy, rusticated stone sills and lintels; a conical roof with an ornate, bracketed cornice caps the tower. A full front porch at the first level is made of stone block. Its roof is upheld by a series of paired, singled fluted columns with Ionic capitals. A wooden balustrade with a series of urn finials crests the roof of the porch. Heavy rusticated stonework surrounds the front entrance door and front window with an engaged stone base support for the tower. On the west side elevation facing Eleventh Street are two-story gabled bay windows and a small carriage porch with elaborate stone steps The house originally had more stained glass windows; however, all but one of these have been removed. Shortly after their marriage Mr. and Mrs. Charles William Campbell came to Huntington to reside and stayed in their new home for the next 28 years.

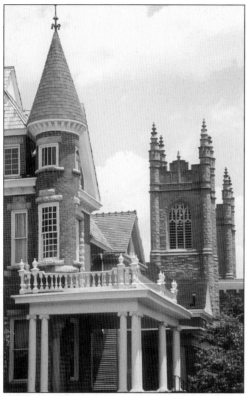

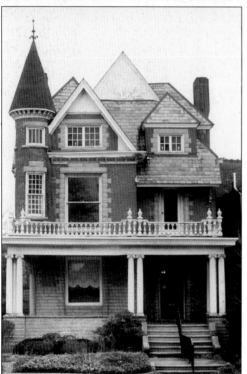

JENNIE RATLIFF CAMPBELL. Jennie Campbell was prominent in affairs of church and state as the First Lady of Huntington. During the numerous campaigns throughout the war and in all church interest she was sought for the value of her suggestion and initiative, making and keeping a host of friends in the execution of her home and public duties. When it became evident that the stress of life had undermined her health she was taken to Baltimore for surgical treatment. However, the demands of her position had been too great, robbing her of the resisting power to withstand a nervous shock. Jennie Campbell died August 7, 1919, at Kelly-Burnham Hospital in Baltimore. The city of Huntington was bowed with grief as Rev. S. Roger Tyler of Trinity Episcopal Church held her funeral in private at her home at 1102 Fifth Avenue. City Hall ordered suspension of activities out of respect to the family. Jennie was the daughter of Nancy Frazier and George Ratliff, an acknowledged leader in the beginning days of Huntington and a justice of the peace who had served in the Civil War. Upon the death of Judge Charles William Campbell in 1935, the Law Society and the Cabell County Bar Association would create a "Resolution" to memorialize Judge Campbell in the State and Federal Courts. Being "Resolved: that the Cabell County Bar Association deeply deplores the death of Charles William Campbell and desire to place upon record an expression of the respect and esteem in which Mr. Campbell was held and of the regret for the loss which the bar and the public have suffered in this untimely death."

GEORGE F. MILLER/DR. C.M. POLAN HOME, BUILT IN 1897 BY ARCHITECT J.B. STEWART.
Eleventh Street, between Fifth and Sixth Avenues, was at the turn of the century a posh residential address. This vast Queen Anne mansion once stood on the northwest corner of Sixth Avenue and Eleventh Street; George F. Miller's neighbors were the Prichards, Campbells, Fosters, and Holzwades. Miller's mansion would be demolished on September 15, 1959, as Meanor & Handloser built the new YMCA. Dr. C.M. Polan, the owner and former resident, stated the site would be used as a parking lot. For many years this charming structure was the home of B'nai B'rith Lodge. George F. Miller's home would be enlarged in 1900, and today the the carriage house, which stands on the corner of the alley on the west side of Eleventh Street between Fifth and Sixth Avenues, is all that remains. When D.I. Smith was elected sheriff, George F. Miller Jr. was made a deputy and served under Smith for six years. Miller then served four more years under his father. George F. Miller Jr. was considered the most constructive businessman of his generation and to enumerate his many business interests would involve a list of all or most of the successful enterprises in Cabell County. He married Lucy B. McDonnell of Catlettsburg, Kentucky, and had four children. Lucy died on January 8, 1889, and he married Florence G. Miller on November 12, 1890, daughter of William Clendenin Miller of Barboursville. The Clendenin family were among the first settlers of Greenbrier County and Charleston, West Virginia, and they were also early settlers of Barboursville.

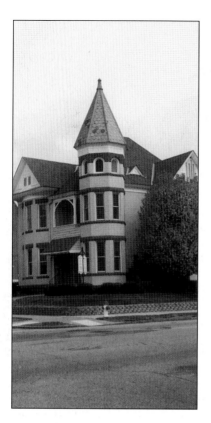

PRICHARD HOME, 1890, ARCHITECT J.B. STEWART. Built in 1890, this elegant, Queen Anne structure is located on the northeast corner of Sixth Avenue and Eleventh Street. It once had a rusticated stone elliptical verandah with Ionic columns and ornate dentil block trim that circled around the turret and extended east on Sixth Avenue, but it has since been removed. The large octagon tower on the upper portion is capped with a conical slate roof. On the second story is a series of balconies with roundel bracket trim; elaborate woodwork exists on the interior, and custom sliding shutters on tracks are at all the windows. In the late 1870s, Fred C. Prichard and Robert Prichard, the sons of Dr. Lewis Prichard, a very wealthy man of Charleston, came to Huntington. Fred dealt largely in real estate and coal interest and built the Prichard Hotel. Karl C. Prichard and Lucy E. Prichard were siblings. Lucy was chairman of the Latin department at Marshall College from 1914 to 1941. She was born in Catlettsburg, Kentucky on October 26, 1876 and was educated in Catlettsburg schools, Vassar College, the University of Chicago, and Columbia University. She also studied at the American Academy in Rome and at the American School of Classical Studies at Athens. She taught at Huntington High School from 1899 to 1913 and served as principal from 1909 to 1913.

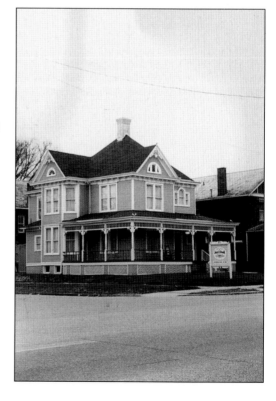

CENTRAL LAND COMPANY, BUILT IN 1888 BY DELOS W. EMMONS. Located at 1349 Sixth Avenue on the southwest side of Fifteenth Street is this charming Victorian Queen Anne ginger bread structure, built by Delos W. Emmons for the Central Land Company, for the residential development of Sixth Avenue area. The elaborate verandah wraps the structure and is typical of the late Victorian style. The front gable has arched windows and a series of brackets are under the eaves; the original balustrades along the verandah have been replaced. Some historical records indicate that a Dr. and Mrs. Harry Keatley lived in the home until 1915. Thomas Way restored the house in 1988, and the residence today is the office of Dr. Jack E. Dodd.

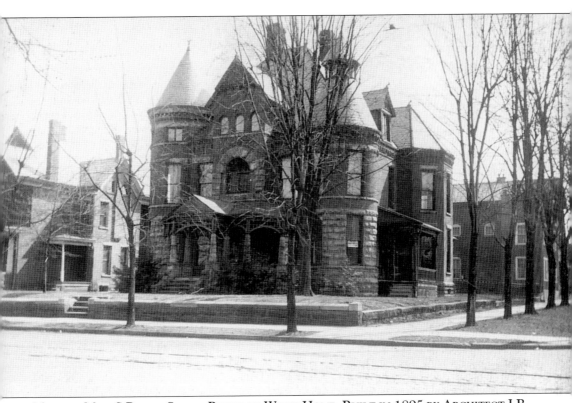

MR. AND MRS. S.P. AND SARAH RICKETTS WILEY HOME, BUILT IN 1895 BY ARCHITECT J.B. STEWART. This imposing Gothic rusticated stone and brick structure is located at 1505 Sixth Avenue and Fifteenth Street. Without question it is one of J.B. Stewart's and Huntington's finest Gothic structures. To the right of the entrance hall is the former library and dining room. To the left is an impressive drawing room. In the rear of the first floor is a powder room, kitchen, and maid's bedroom. On the second floor is a central hall with a second-story porch in the central arch of the structure. From the front back on the left is the former master bedroom and bath suite. To the right are two guest bedrooms and in the rear of second floor are another bedroom and two baths flanking a rear servant's staircase. The original floor plans were changed in 1838 when architect Sidney L. Day converted the former S.P. Wiley residence into a series of apartments. The front rusticated stone porch and entrance had a series of tapered stone columns supporting a trellis-arched verandah. Today the imposing Gothic structure has been painted and many of the upper windows have been enclosed. S.P. Wiley was chief of police in Huntington in 1899–1901. Later the home would be the residence of Robert L. Archer, who began his career as a collection clerk in the Old First National Bank in 1890 and continued until his election as vice president in 1920. Robert L. Archer would become president of the Union Bank and Trust Company, serving from 1923 to 1931.

ALBERT E. COX HOME, BUILT IN 1896 BY ARCHITECT J.B. STEWART. Located on the northeast corner of Fifteenth Street and Third Avenue, this imposing four-story, late Queen Anne and early Edwardian structure sits on an impressive rusticated stone foundation. The red brick structure supports a variety of architectural ornamentation in stone and various colors of brick and terra cotta banding. The front façade and round verandah are detailed rusticated stone with smooth squared stone columns and railings that terminate into the steps in a Roman acanthus leaf design. The original stained glass windows are missing. Albert E. Cox's business covered a decade of purchasing over 58 bankrupt businesses and disposing of them successfully. His permanent stock included china, glass, queensware, tinware, lamps, refrigerators, stoves, bicycles, and home furnishing specialties, which were sold at wholesale prices. He occupied a four-story building and carried complete stock all the time. In June 1897, his store was gutted by fire and Cox simply held a large fire sale and reopened, purchasing a larger and finer stock. He also owned considerable property in the city of Huntington. Seven miles east of Huntington the B&O had a station, known as Cox's Landing, which was established by Albert's grandfather, William Cox, from Buckingham County, Virginia. William moved to Mason County in 1795; in 1811 he married Sarah White and moved to Cabell County, where he remained until 1835 when he purchased a plantation farm from Adam Woodyard. William opened a store near the bank of the Ohio River; Cox's Landing remained in business for many years. It was the principle location for local families supporting and furthering the cause of black individuals longing for freedom and reaching Getaway, Ohio. William's son John Cox married a Miss Miller from Guyandotte. John and his wife were the parents of Albert E. Cox, who was born at Cox's Landing and worked in his father's general store.

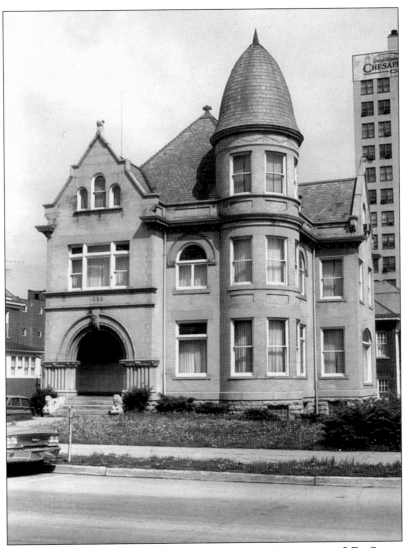

WILLIAM HENRY HOLSWADE HOME, BUILT IN 1897 BY ARCHITECT J.B. STEWART. The Holswade home was once located on the northwest corner of Eleventh Street and Fifth Avenue. The impressive brick-and-stone structure had a tile roof in a verdigris blue green color and an ornate gable in the Flemish style. William Henry Harrison Holswade's family begins with Christian F. Holswade, who arrived in America on August 14, 1819, and died June 14, 1876. He was a Prussian immigrant who moved to Lewis County, Virginia, and married Martha A. Alikre. William Henry Holswade was born in Lewis County and moved to Roane County as a child. In his late teens he entered Marshall College and worked as a clerk in the first post office, where he served for two years. He eventually went into the furniture business. William married Georgalla Gallaher, and in time, the Holswades had built up an extraordinary business and had a store on the south side of Third Avenue between Ninth and Tenth Streets. His son James Frederick Holswade continued the business until 1915 when an advantageous lease to Kresage and Company was offered. James, president of the Security Savings Bank and director of First National Bank, married Daisy Leona Staats, daughter of Coleman and Emma Watkins Kenney Staats, in 1905. Georgalla Holswade died in 1905 and William Henry died in 1908. James Frederick Holswade died in 1942 and Daisy Staats Holswade in 1946.

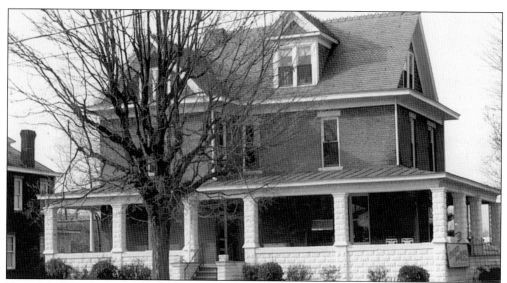

NICHOLS-DOBER HOME, BUILT IN 1899 BY ARCHITECTS WALTER & RANDOLPH. Located on the southwest corner of Ninth Street and Eighth Avenue stands the Nichols-Dober home. The Nichols family were early settlers of Greenbrier County, Virginia. Joseph H. Nichols and his wife Mary built this handsome red brick Georgian structure with a tile roof and a series of dormers. A rusticated stone verandah with stone columns wraps the home. The front door and windows are heavy beveled lead crystal; an impressive entrance hall supports an Edwardian staircase. The Nichols family occupied this graceful structure until 1922. Joseph Nichols sold the home to Paul Dober, a German citizen who came to America as a small boy and engaged in business in Gallipolis, Ohio. In 1899, Paul loaded his stock of merchandise on a boat and moved to Huntington and started a tailoring business on Third Avenue and Tenth Street. The Dober family lived in the home from 1922 to 1990, with two daughters, Eva and Josefa.

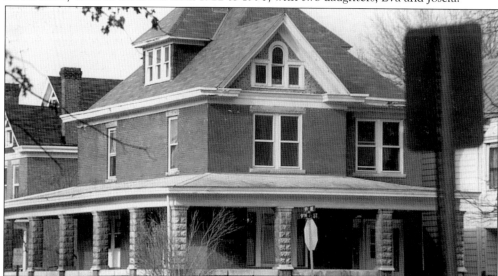

Nichols also built this Georgian structure on the corner of Ninth Avenue and Ninth Street. He purchased the entire block of Ninth Street between Eighth and Ninth Avenues and subdivided the lots between the two structures for development in 1905. Son Harry C. Nichols was a local dentist and participated in the West Virginia Hotel in 1917.

LOUISE STEWART THOMPSON. Louise Stewart Thompson lived for 70 years in her childhood home at 1018 Fifth Avenue. Her father, James B. Stewart, was the architect who built the charming structure in 1897. He was the supervising architect of the Cabell County Courthouse, the impressive Renaissance post office on Fifth Avenue, the Cabell County Public Library, and the First Presbyterian Church, along with many of the distinguished homes in Huntington. Mrs. Thompson was the widow of Mr. J. Ferguson Thompson, a well-known Huntington real estate broker.

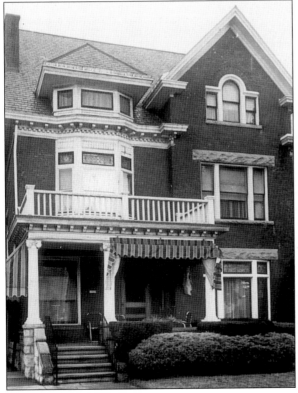

JAMES B. STEWART HOME . Stewart was one of Huntington's earliest and most prominent architects. Many of the early homes in this book reflect his impressive architectural achievements. This handsome Victorian structure was built in 1897. The front door was adorned with wrought iron work and leaded crystal and led into a pleasant 10-room home. J.B. Stewart died at the age of 49 in 1908 and left the home to his daughter. Relatives lived in the adjoining homes—grandparents on one side, aunts on the other. The Stewart and Thompson families shared the city block with the Holswade and McClintock families. Urban renewal would eventually lay claim to these architectural gems. Today, Bank One on Fifth Avenue between Tenth and Eleventh Streets occupies the once formal residential area.

BRADLEY WATERS FOSTER AND MARY LENORA HUNTINGTON FOSTER. B.W. Foster was born on a farm in east Maine. As a young man he traveled to Cohoes, New York, to begin his life in the business world. He left Cohoes for Oneonta, New York, in 1868, where he married Mary Lenora Huntington, a niece of Collis P. Huntington. B.W. and Mary arrived in Guyandotte in 1871 and took up residence there until the first lot sale was held in the new city of Huntington. They purchased several lots—one lot was to build their new home on the southwest corner of Fifth Avenue and Eleventh Street, and the other lot was at the southwest corner of Third Avenue and Ninth Street, where B.W. later built the Foster Hardware Building. The hardware business boomed and the old structure was replaced with a three-story, Romanesque-style, brick and rusticated stone structure that was completed in 1894. Lake Polan III recently restored the Foster Building in 1997. In 1906, the Foster-Thornburg Hardware Company moved to Second Avenue and Twelfth Street. Forster-Thornburg Company was in business until 1965.

The First National Bank was chartered in 1892. He was a member of the city council and directed a committee to incorporate the town's first hospital. In 1894 B.W. and other citizens organized and chartered the Huntington Chamber of Commerce. In 1903 B.W. became the third president of the Huntington Land Company, which stemmed from the Central Land Company headed by Collis P. Huntington. Upon the completion of the Guyandotte Valley Railroad, a vast demand of real estate in Huntington made B.W. a wealthy man. George Selden Wallace, author of *The Annals of Cabell County*, wrote of Foster that he was "the type of capitalist who felt that the custodian-ship of large wealth carried with it a social responsibility to the community from which it evolved." B.W. had a frugal sense; he would constantly use old newspapers at all of the windows to cut down on the heating bills. His frugality would later pay off when he created the well-endowed Foster Foundation. Mary died in 1920, two years before her husband's death. The Fosters had no children and the well endowed trust and estate went to the creation of The Foster Foundation.

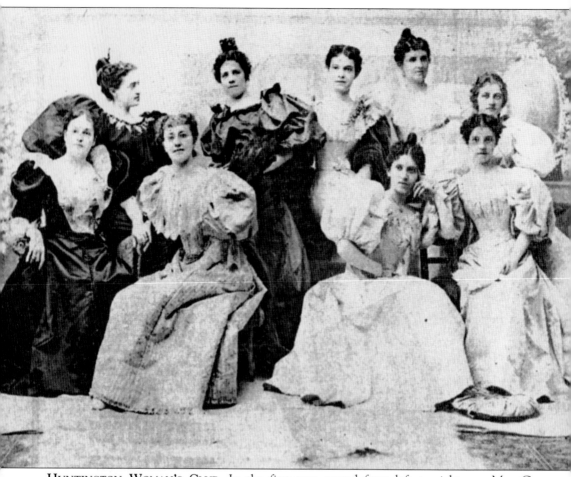

HUNTINGTON WOMAN'S CLUB. In the first row, seated from left to right, are Mrs. Gus Honshel, Mrs. Edward Bliss Enslow, Miss Elizabeth Biggs, and Miss Lillian Frye. In the second row, standing from left to right, are Miss Grace Shepard, Mrs. Henry O. Aleshire, Miss Lucie Frye, Miss Wille Beardsley, and Mrs. F.A. McDonald. Other early members were Miss Annie Comer, Miss Bess Sheon, and Mrs. Nelson Cecil of Wheeling. The late Mrs. Morton Wortham Sloan founded the Woman's Club of Huntington. Mrs. Grace La Ferre Cammack was the woman's club first treasurer and served as president from 1919 to 1920. She was one of the small group of women who "conceived and steadfastly held a vision of an organization that would reflect the desire of a woman in large number."

MRS. H.A. BRADENEBURY. Mrs. H.A. Bradenebury held the second official meeting of the Woman's Club of Huntington. Dr. and Mrs. Ida Hanning Bradenebury lived at 931 Sixth Avenue. After the city of Huntington was incorporated and business began to center there, Dr. H.A. Bradenebury was among the early doctors and also served as mayor of Huntington. Miss Ann Skelton of Brooklyn, New York, was a studious woman who focused quickly on the realities in Huntington. Through her own courtesy, a group of 30 women were invited to gather in the library of the late Henry C. Simms home, located at 1137 Third Avenue, to hear for the first time a proposal for the organization of a "Woman's Literary Club." This meeting was held on October 8, 1898; 15 of the women expressed a willingness to help and an organizational meeting was set for the following week at the home of Ida Bradenebury. The meeting was held on a cold and stormy afternoon and when the clock struck 5 p.m., the only women who had arrived allotted the offices among themselves. They were Mrs. Morton Wortham Sloan, president, who kept that office for the first 10 years of the organization, resigning only to accept the State Presidency of the Federation; Mrs. Ida Hanning Brandebury, vice-president; Mrs. Harrett Vinton Haworth, secretary; and Mrs. Grace La Ferre Cammack, treasurer.

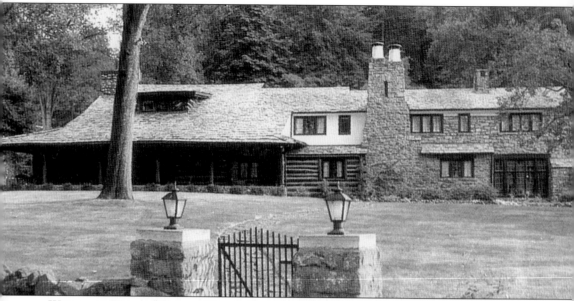

WHITAKER-HAGER-HAYDEN HOME, FORMER 350-ACRE WHITAKER ESTATE, BUILT 1897 AND 1907, ARCHITECTS J.B. STEWART AND EDWIN N. ALGER. Located on what was once the Old James River Turnpike (today Whitaker Boulevard) stands a masterpiece of the Aesthetic Movement and the Arts & Crafts style of architecture. This home covers 6,000 square feet and boasts a botanical garden with a lily pond. There are graceful cobblestone paths and walls with dogwood and an extremely rare Japanese Split-leaf Maple tree planted by Mrs. Whitaker in 1904. Frank L. Whitaker was born on February 15, 1861, at Cape May Court House, New Jersey. He played a powerful part in the evolution and the development of Huntington. On October 1, 1885, Frank married Sanderson Kitzing of Liberty, Pennsylvania. Mr. and Mrs. Whitaker and their two daughters arrived in Huntington in 1904 to take up residence in this large and impressive home at 1250 Fifth Avenue. Whitaker was a member of the First Presbyterian Church of Huntington, and he was also in constant support of the affairs of Trinity Episcopal Church, of which Mrs. Whitaker and her daughters were members. Known as a kind and generous man, he was an active member of the Elks Club and Kiwanis Club. Frank L. Whitaker was the first president of the Day & Night Bank. He had little regard for the strict demands of social aspirations; he kept his door open to his friends and acquaintances and those often in need. On October 7, 1916, Mr. and Mrs. Samuel Patton Hager purchased Frank L. Whitaker's estate, which had gone from 350 acres to 4.3 acres in 1916. The Hagers came to Huntington in 1909 when Mr. Hager joined J.M. McCoach & Company, a cold storage and ice concern. Later the home became the residence of the Hayden family for nearly 50 years. William Omar Hayden died on February 17, 1981. In 1988, Dr. Constance Hayden, his daughter, was a psychiatrist and teaching professor at the Uniform Services Medical Center, a division of Walter Reed Hospital in Washington, D.C. Dr. Hayden was also Psychiatric Consultant to the National Security Agency. Her husband, Dr. Ansinelli, was chief cardiologist consultant to the United States Senate from 1982 to 1984. They purchased the home from Dr. Hayden's mother. The couple has two young sons, Michael and Hayden Ansinelli.

Four

OLD CENTRAL CITY

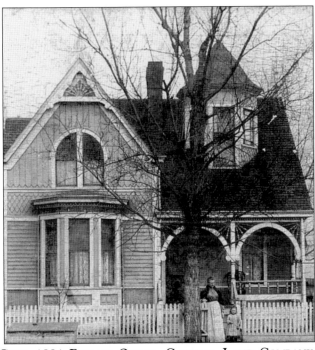

OLD CENTRAL CITY, 1891 FORMER OFFICE, CENTRAL LAND COMPANY, MESTEL FAMILY HOME BUILT 1901–1903. With the expansion and development of Huntington in the early 1890s, a group of investors organized the Kenova Land Company and purchased several farms west of Huntington. Next, they laid out a new town called "Central City." The leaders in this venture were L .Caldwell, George F. Miller, George McKendree, S.S. Vinson, and Z.T. Vinson. Grants were offered to factories, and a variety of manufacturing industries soon located there. Central City's development map was filed on October 6, 1891, and a short time afterwards there was a successful sale of town lots in the new village. The city was incorporated on July 31, 1893, and M.W. Chapman was the first mayor. After Central City was incorporated, three glass companies located in the new city and built factories, which operated for some years. The first glass plant was built by Addison Thompson in 1895. Two were begun by L.H. Cox and went down in the panic of 1898. Taking over both of Cox's plants, Forbes Holton operated as the Union Glass Works until 1904, when he sold to Antion Zihlman, who had begun the Huntington Tumbler Company in 1900. Tumbler's goblets and general line of lead-blown tableware were manufactured in a large brick factory facing Fifteenth Street West between Jefferson and Madison Avenues. Glassware was sold to all parts of the United States, Latin America, and Europe until the business collapse of 1929; the factory closed in 1932. Wood was another of the materials processed by several of the Central City plants, which included the Hartzell's handle factory and the Central City Bung Company, which operated from 1894 to 1918 manufacturing hardwood plugs for filling holes in barrels.

GERTRUDE AND FREDERICK MESTEL. The Queen Anne home on the previous page was built in 1891–1892 on Washington Avenue as the offices and home of the Kenova Land Company. This charming structure has served as a post office for Central City. In 1901 the Mestel family purchased the home and it remained in that family until Frederick Mestel's death in 2003. Gertrude and Frederick Mestel are pictured here.

THE FESENMEIER BREWERY, 1899. An early Central City industry, the American Brewing Company constructed a large building at the corner of Madison Avenue and Fourteenth Street West, which was taken over in 1899 by the West Virginia Brewing Company. It was operated successfully until the state adopted Prohibition in 1914. The ice plant was continued with Fesenmeier Packing Plant starting the next year and cold storage added to that in 1922. After the repeal in 1934, the brewery business was resumed as the Fesenmeier Brewing Company; more than 30 years later the name was changed to the Little Switzerland Brewing Company when the plant was sold. The handsome edifice of the brewery was finally demolished and is now the West Land Plaza shopping center.

CHARLES AND KATE HEINER, OLD CENTRAL CITY.
Charles Wesley Heiner was born in Ironton, Ohio, in 1848; he and his brother Frank started Heiner's Bakery in 1905 in Central City on Washington Avenue and Thirteenth Street West. Frank Heiner would sell his share of Heiner's Bakery in 1909. Charles Heiner married Kate Schneider, who was born in Germany in 1881. Kate worked at various jobs in the bakery and was a devoted wife and mother to her sons. Clifford Heiner, born in 1902, was very active in the Bakery Business until he sold his shares in 1950. Clifford married Lucille Cooksey from Grayson, Kentucky. Clifford Jr. was born in 1926 and became a dentist and married twice; he died in 1980.

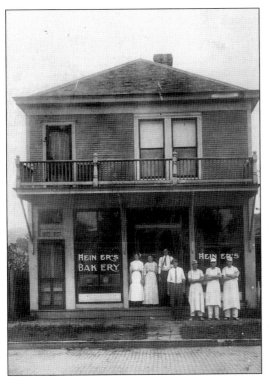

HEINER BAKERY, OLD CENTRAL CITY.
Charles and Kate's second son, Earl Wesley Heiner, born in 1904, grew up in the family business and managed the bakery. Earl married Florence Crow (1909–1975) from Camilla, Georgia. After she died, Earl married Anagene "Plymale" Bartram. Of the union with Florence were born two children: Earleen Heiner, born in 1933, and Earl Wesley Heiner Jr., born in 1935. Earl Jr. married Nancy Eddy, the daughter of Mr. and Mrs. Charles Eddy, an optometrist. Earleen married Robert Agee, who was born in 1929 and is vice-president of Heiner's Bakery. Robert is the son of Mr. and Mrs. Floyed and Ada Pryor Agee. Floyd L. Agee was president of the former Agee Department Store in Huntington and director of the Bankers Finance Corporation and Security Reality Company. Earleen Heiner Agee works at Reuschelin Jewelers and is active in community affairs.

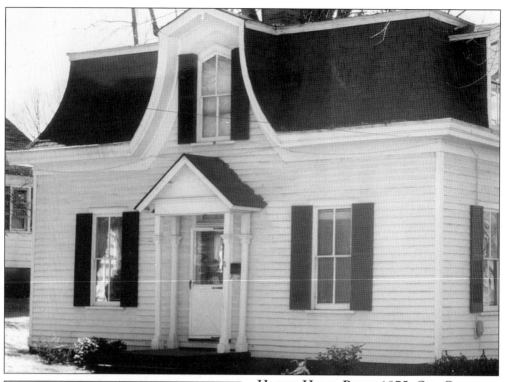

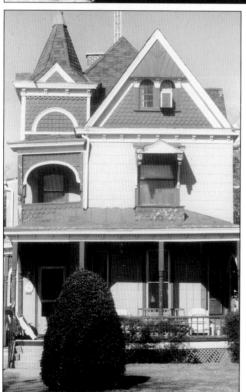

HARRIS HOME, BUILT 1875, OLD CENTRAL CITY. Located at Ninth Street West, this charming, French Queen Anne, one and a half–story structure was built by Joseph and Nan Harris in 1875. The home is painted wood lap siding; the upper half story is sheltered beneath a concave profile mansard roof. Gabled dormers at the side elevation house coupled windows with point sash. The house was moved to its present location in the 1950s from a point across the street.

SURBOUGH-FERGUSON HOME, BUILT 1893. Located at 910 Madison Avenue, this whimsical, late Queen Anne, frame house is modest in size but gracefully designed with brackets, turned posts, and elaborate shingle work applied to the square tower that is crowned with a single conical cap. The third floor dormer rests on brackets; the window has wood pendants. The tower houses a half-story spiral stair, while another interior feature is the first floor bracketed parlor mantel. Alterations include a room added to the west side of the house. Later the Pollard and Scott families occupied the home.

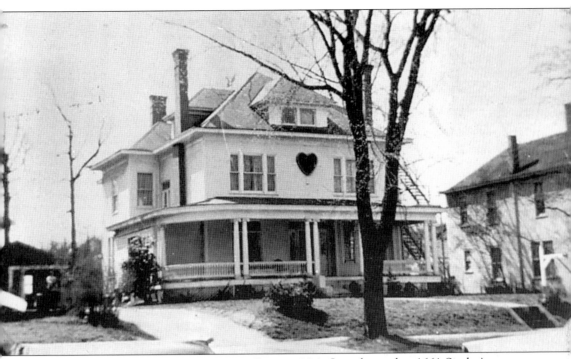

LAURENCE FRANKLIN CAVENDISH HOME, BUILT 1906. Once located at 1661 Sixth Avenue, the Cavendish home was another Edwardian expression. The elliptical verandah wraps the structure with a series of paired Ionic columns and a decorative balustrade. Joseph Henry Cavendish was the son of Laurence and Lucy Cavendish. He was a World War II foreign correspondent and assistant editor of *Newsweek*; he later worked as a court reporter with the *Miami News*. Joseph Henry married Margaret McKenny and lived in Florida for 20 years. He worked for Grady Resin Realty. In 1953, Joseph Henry sold the house for his mother to Gamma Sigma Epsilon. The funds and proceeds were placed in the widow's trust at the Twentieth Street Bank for Lucy Cavendish.

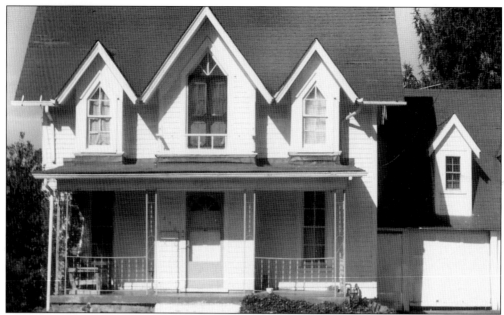

LAWRENCE CAVENDISH HOME, BUILT 1900. This Gothic style house is located at 830 Jefferson Avenue and was originally known as the Lawrence Cavendish home. The structure is a white, wood frame, Carpenter Gothic style that had some alterations to the front porch. Built around 1898, the home later became the residence of George Cavendish and his family.

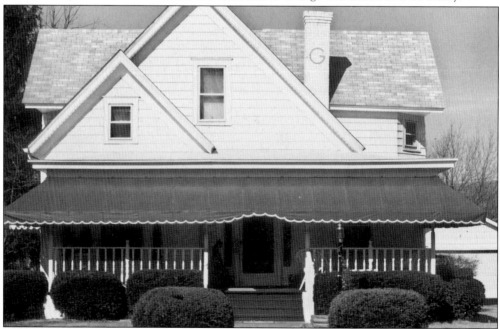

LESLIE CAVENDISH HOME, BUILT 1900. The Cavendish families lived side by side; Lawrence and Leslie along with a third brother operated the Cavendish Brothers Department Store, which was probably the best known store in West Huntington. Joseph Franklin Cavendish (1841–1920) came to Central City in 1900 from Fayette County as a business manager of the *West Virginia Baptist Newspaper*.

Five

HISTORIC CHURCHES

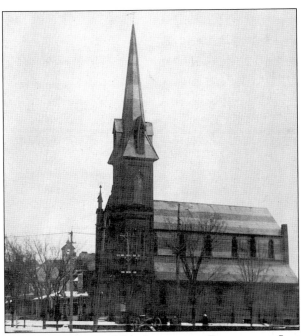

FIRST CONGREGATIONAL CHURCH, 1874, ARCHITECT REMBRANDT LOCKWOOD, NEW YORK CITY. Huntington's first church began in 1872. Collis P. Huntington was approached concerning a park that would be located on the Ohio River and extend from Twentieth Street to Sixteenth Street. The public park would serve Marshall College and the new citizens of Huntington; however, one of Huntington's associates, A.S. Hatch of the firm of Fisk and Hatch of New York, was a New Englander, a Congregationalist, and among the numerous people who had moved to the new city of Huntington who were also of this faith. The Hatch family asked Rev. Joseph E. Roy to investigate the situation in Huntington and report back to them with the outlook for the establishment of a Congregational Church. Reverend Roy gave a favorable report. Hatch proposed that he would contribute $4,000 towards the construction of the new church in Huntington if the local people would raise an equal amount. His original contribution was modified in that Mr. Hatch—and his associates Harvey Fisk, A.A. Lowe, Collis P. Huntington, William H. Aspinwall, William Washington, and James H. Stoors—agreed to donate $6,000 to build a $10,000 church. The 13 charter members of the new proposed church were E.E. Randell, Aaron Walker, H.S. Clark, Rhoda M. Clark, Rev. Jos. E. Roy, Lynda M. Proctor, Merton H. Brooks, C.F. Parsons, H. Chester Parsons, Nellie C. Parsons, T.B. Campbell, and Elizabeth J. Campbell. On June 15, 1872, the board of trustees instructed the members to secure the property on the southeast corner of Ninth Street and Fifth Avenue and to proceed with construction. Collis P. Huntington and Delos W. Emmons proposed to the trustees that if they would erect a church to cost no less than $11,000, they would donate the property. The city council approved the plans and Randell was made deacon of the newly organized church.

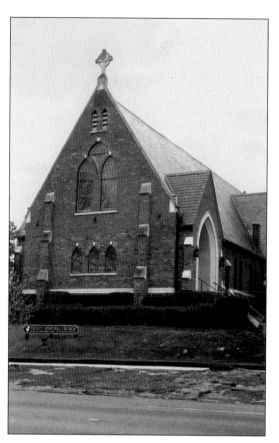

TRINITY EPISCOPAL CHURCH, ARCHITECT CHARLES W. CASSELL, 1884. The early roots of Trinity Scot-Episcopal began in the late 1790s, stemming from Greenbrier County through the New River and Teays Valley into Guyandotte and Barboursville in the early 1820s. John Laidley assisted in creating the first chapel in Huntington at Marshall Academy. After the Civil War and the burning of Guyandotte, services were held in Barboursville. On October 22, 1867, Rev. Horace Hayden held the services and a meeting to establish a parish and a church called Trinity. Services were held at the Barboursville Courthouse monthly. Located today on the southeast corner of Fifth Avenue and Eleventh Street, the Trinity Episcopal Congregation was founded in 1869 in Barboursville and moved to Huntington in 1872. Charles E. Cassell, an architect from Baltimore, designed this Gothic English chapel of red brick and sandstone trim; it was completed in 1884. The lancet shaped stained glass windows are by Louis Comfort Tiffany and Willet Stained Glass Studios.

ST. JOSEPH CATHOLIC CHURCH, 1889. St Joseph Catholic Church is located on Thirteenth Street between Fifth and Sixth Avenues. After several early major floods in Huntington, Father Weringer chose this site because it sat above the floodwaters. The elegant double wooden doors are housed in a Gothic arch leading to a vestibule. Above the entrance is a rose stained glass window set in smooth stone. Above the roundel is a recessed niche housing a saint. A cross is positioned at the top of the graceful stone gable.

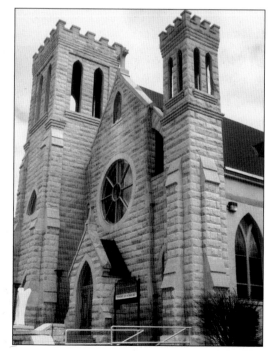

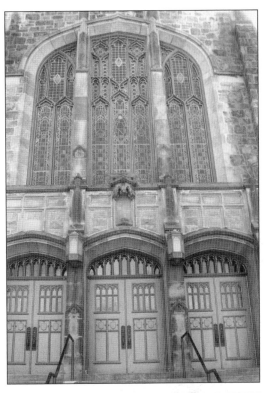

JOHNSON MEMORIAL UNITED METHODIST EPISCOPAL CHURCH, BUILT 1886.

Located on the southwest corner of Tenth Street and Fifth Avenue stands one of Huntington's finest Roman Gothic revival churches. Built in 1886 the rusticated brownstone memorial was destroyed by fire in 1894; the church continued on the site and rebuilt a Roman Gothic church in 1912 with a seven-story bell tower. Peace would rule the new church until the early morning of December 9, 1935. As the city held a wide religious observance, flames roared through the edifice consuming all the furnishings, leaving one of Huntington's largest churches in ashes. The history of Johnson Memorial Episcopal Church South dates back to Bishop Francis Asbury, a stalwart of Methodism in post-Revolutionary days, who visited Guyandotte in 1804. Through his efforts William Buffington dedicated a site in the town for the construction of the first Methodist Church facing the Guyandotte River. Rev. William Steele, a circuit rider preacher, assumed the pastorate in 1804, when the church set apart a burial ground in the rear. This denomination divided nationally in 1844 over the issue of slavery, and the church building became a schoolhouse. The Southern Methodists withdrew and built another church on Main Street on land donated by Robert Holderby. The main branch of Methodism established a church in Marshall Academy, until the academy was turned over to the state.

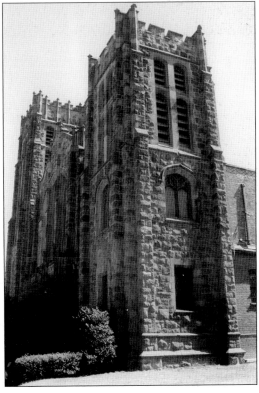

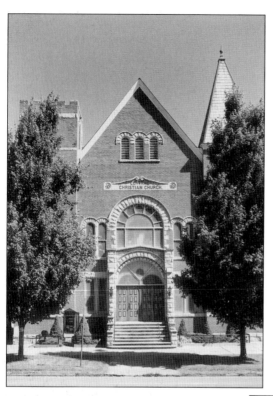

CENTRAL CHRISTIAN CHURCH, BUILT 1895. Located on the northeast corner of Fifth Avenue and Twelfth Street, the Central Christian Church was built in 1893. This property was purchased and the groundbreaking ceremonies were held in May 1895; the cornerstone was laid June 26, 1896. This Renaissance-style structure has a central gable that is flanked by battlement towers and a valence of arches in rusticated stone that caps the windows. The bell tower to the left had several stories removed from the top due to structural damage from and renovations after the 1913 flood. This same year, the Central Christian Church purchased a new pipe organ. A colonnade of arches that encloses a garden and the education building were finished in 1953.

FIRST PRESBYTERIAN CHURCH, BUILT IN 1895 BY ARCHITECT J.B. STEWART. Officially established on July 28, 1838, the First Presbyterian Church began at Marshall Academy. Later the Methodists and Presbyterians of Huntington shared a church on Seventh Avenue and Sixteenth Street until the present church was built. Located on the south side of Fifth Avenue between Tenth and Eleventh Streets, this massive and imposing rusticated stone structure has a central stone façade that terminates in a Gothic arch. Two Renaissance battlement towers with parapets and lancet openings flank the principle entrance, which is a hood arch with recessed roped floral and ribbon banding. Stone arches rest on heavily carved ornamented half columns with carved capitals. Above the principle entrance is a recessed arcade of Gothic arched stained glass windows with dentil banding. Above that is a Gothic arched one-story stained glass window with smooth sandstone banding flanked by lancet windows.

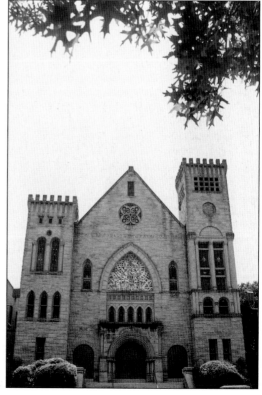

FIRST CONGREGATIONAL CHURCH, BUILT IN 1911 BY ARCHITECT EDWIN N. ALGER. Located at 701 Fifth Avenue and Seventh Street, the First Congregational Church was organized in 1872 with Rev. Joseph E. Roy presiding. The initiative to build the church came from A.S. Hatch, a member of the New York firm of Fisk and Hatch, financial backers of Collis P. Huntington. Huntington and Hatch both shared a New England background, and both were anxious to have New Englanders take advantage of the promising opportunities soon to be present in the new City of Huntington. The original church was located where the Fifth Avenue Hotel stands today. Despite the nationwide depression of 1874, the First Congregational Church started construction of the first church edifice. This massive and utterly overwhelming edifice in the late neo-Gothic style dominated the skyline of Huntington until it was demolished in 1908. On April 16, 1911, the cornerstone for the present church was placed.

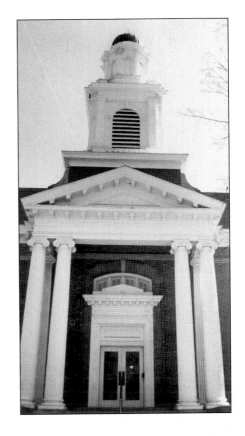

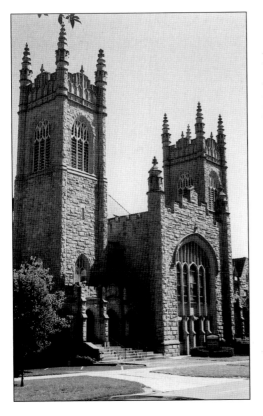

FIRST UNITED METHODIST CHURCH, BUILT 1913–1914. On the northwest corner of Twelfth Street and Fifth Avenue stands one of Huntington's architectural jewels. Built of Cleveland gray sandstone with a red tile roof, this English Gothic architecture is noted for geometric and flowing tracery, enlarged clerestories, and stellar vaulting. It is one of the crowing achievements of the Edwardian period. Two stone arched entrances with tile floor loggias and a cloister on the west side entrance flank the central chapel. Two massive stone battlement towers give a Cathedral appearance. Each tower is 100 feet high with elaborate turrets topped with finials. These impressive towers are reproductions of the Magdalene Towers of Oxford. Upon entering the cloisters, a Gothic stairway greets visitors. Inside the auditorium are massive pillars with splendid Corinthian capitals supporting widespread arches. The building construction was impeded by default of the contracting company and damage from the 1913 flood.

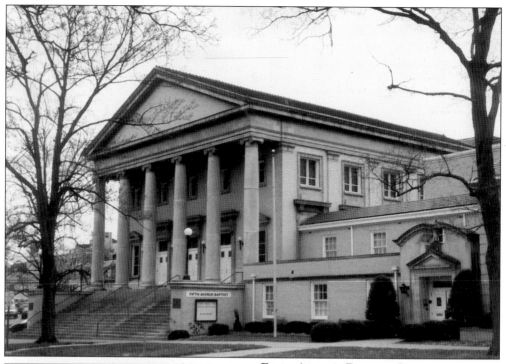

FIFTH AVENUE BAPTIST CHURCH, ARCHITECT R.H. HUNT, BUILT 1916. On the southwest corner of Twelfth Street and Fifth Avenue stands the classical Fifth Avenue Baptist Church. Its history began on August 10, 1872. Rev. A.M. Simms, pastor of the Guyandotte Baptist Church, called a meeting of Baptists for the purpose of organizing a church. The church was organized October 20, 1872. The original church stood on the northwest corner of Tenth Street and Fifth Avenue, where the *Herald-Dispatch* newspaper building stands today. In August 1917, the cornerstone of the present church was laid. This massive Roman edifice has six two-story Ionic stone columns supporting the impressive entablature. The main entrance sits one-story above the ground. Elaborate Roman stone casing with egg and dart trim frame the three double-door entrances. The exterior edifice is a cream brick laid in a Flemish bond pattern.

HISTORIC HUNTINGTON

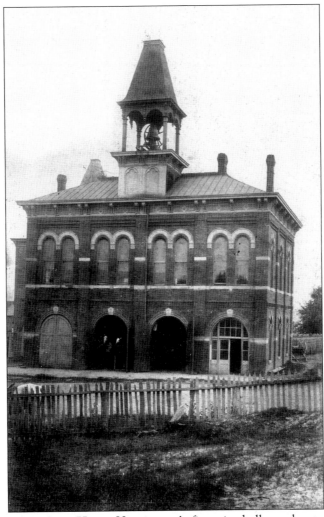

HUNTINGTON'S FIRST CITY HALL. Huntington's first city hall was located on East Ninth Street, between Fourth and Fifth Avenues. Peter Cline Buffington was the first mayor in 1872; Gen. John H. Oley was the first city recorder; Isaac T. Mitchell was the first town marshall; J.H. Poage was city treasurer; L.L. Burks was the city assessor; A.J. Enslow was city street commissioner; and J.W Verlander was the first fire chief. Architect J.B. Stewart designed Huntington's first city hall and jail. The original two standing structures had towers. The three-story structure on the left served as the city and county jail. Later, upon moving the offices of the Cabell County Court House, an extension was added to the city hall section.

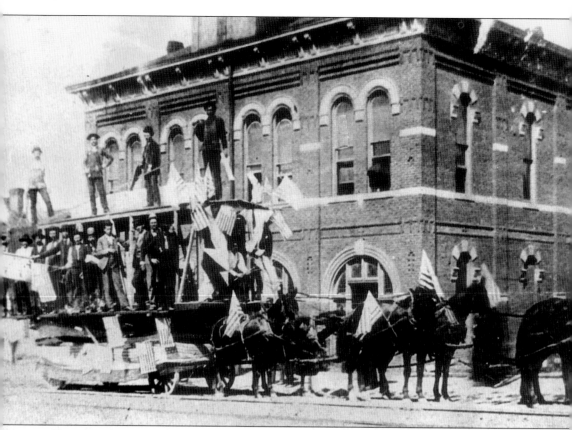

Huntington, July 4, 1876. Huntington's celebration of America's first centennial in July 1876 was a festive event shared by the entire community. A parade was held and bands marched up Ninth Street, passing city hall. The location of the Frederick Hotel today was once an open field; one could view Emmons Hawkins Hardware on the corner of Ninth Street and Third Avenue. Standing on Tenth Street between Fourth and Fifth Avenue was the city's busiest saw mill. William Jennings Bryan, former candidate for president of the United States, was a guest at the Harvey home on Third Avenue.

HUNTINGTON. This view from around Eighth Street and the Ohio River depicts the steamer *Potomac* of the White Course Line, transferring freight from the new C&O rail cars. Huntington was still a city of unpaved streets; iron hitching posts and watering troughs often covered the corner intersections of the streets and avenues. Many of the prominent homes had small stone or cement steps for the convenience of getting into or out of carriages; also the steps served as a mount for ladies who wanted to ride their horse sidesaddle.

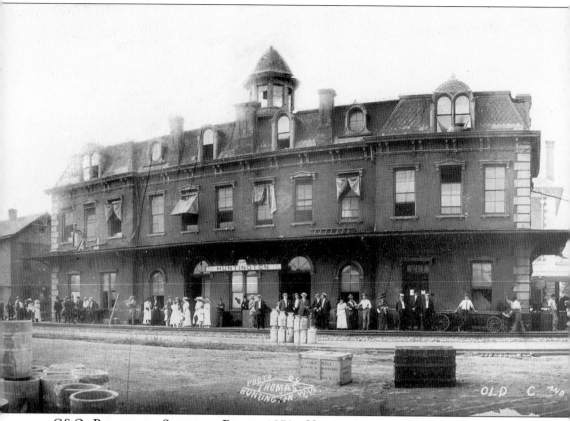

C&O PASSENGER STATION, BUILT 1873. Huntington's C&O Passenger Station was completed in 1873 by the architectural firm working for the railroad company in New York. The building is Second Empire French Renaissance style with a mansard roof supporting a series of arched domes and ornamented brick chimneys capped with a windowpane cupola. A new passenger station was completed in 1913. The old passenger station was demolished in 1914. (Photograph Courtesy WSAZ Channel-3.)

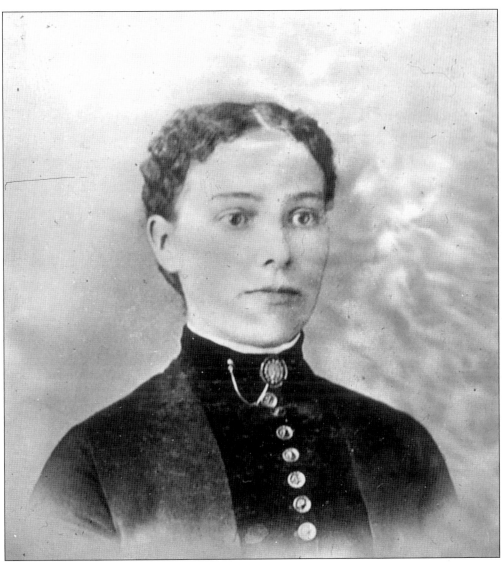

MARGARET LALLANCE. Margaret Lallance was a widow with six sons; she moved from Meigs County, Ohio, to Huntington and opened a millinery shop. Later she purchased a lot on the south side of Third Avenue, between Ninth and Tenth Streets, which she owned for many years. One of her sons, John B. Lallance, worked for the C&O Railroad in 1873. He had a planning mill at the foot of Thirteenth Street and the Ohio River, and he was later a building contractor. Charles N. Lallance was the builder and architect of the former Davis Opera House in 1884. The opera house still stands today on the southeast corner of Eight Street and Third Avenue; it is known as the Bazaar Building today. The former opera house was also used as the first Masonic Temple and a meeting place for Baptists. Another son, Robert Lallance, was a well-known and respected judge in Cabell County; he died in March 1907. Margaret Lallance died in 1914, just a few months shy of her 100th birthday.

THE DAVIS OPERA HOUSE, ARCHITECT J.B. STEWART, BUILDER CHARLES N. LALLANCE, 1884. B.T. Davis purchased the lot from Central Land Company for the Davis Opera House; today it is the Bazaar Building. Davis hired talented architect J.B. Stewart and builder Charles N. Lallance to design the impressive three-story brick building with ornate crown cornice. Davis maintained a drug store on the ground level, while the opera house occupied the upper part of the building. In 1892, Davis renovated the building to seat 1,200 people and renamed it the Huntington Theater. There were eight private boxes draped with velvet, golden cords, and tassels. The main theater entrance was on Eighth Street. Some of the renowned and prominent performers who entertained here were Sarah Bernhardt, John Barrymore, Sophie Tucker, Eddie Foy, Will Rogers, and Helen Hays. With the advent of the moving picture industry in the early 1920s the theater fell into disuse. It was at that time that Walter Lewis bought it and converted it into retail use. Several businesses have occupied the facility, including a city market, Montgomery Ward, and more recently the Bazaar. Today the building has a Regency-style appearance with black marble panels and molded stone encasing for the upper windows due to the creative efforts of Walter Lewis.

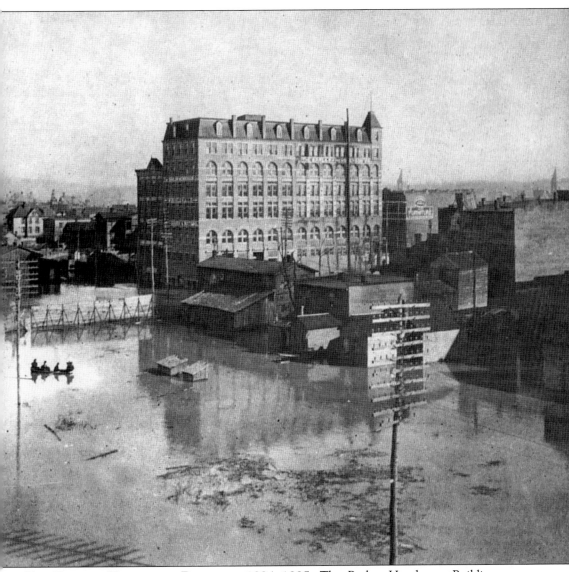

THE BARLOW HENDERSON BUILDING, 1894–1895. The Barlow-Henderson Building was Huntington's first skyscraper. Completed in 1895 on the northeast corner of Third Avenue and Eleventh Street, this imposing stone and brick nine-story structure would burn nearly to the ground in 1905. Subsequent skyscrapers that were built in Huntington were the Robinson-Prichard Building, a 10-story Edwardian structure completed in 1910, and the 12-story First Huntington National Bank Building, designed by architect Verus T. Ritter and completed in 1913.

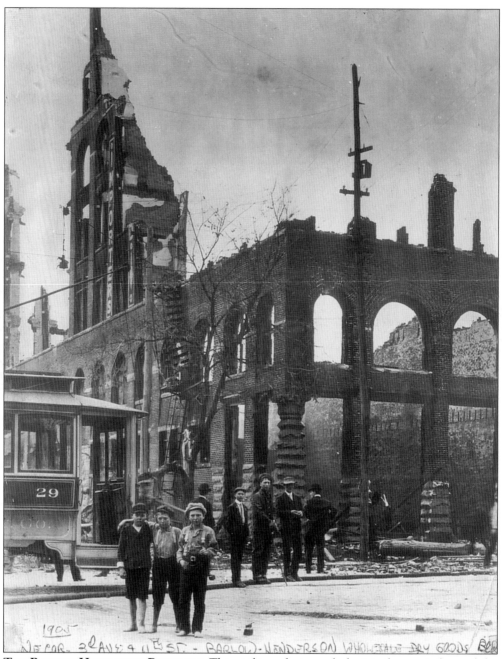

THE BARLOW HENDERSON BUILDING. This striking photograph depicts the tragic fire and the remains of the Barlow Henderson Building in 1905.

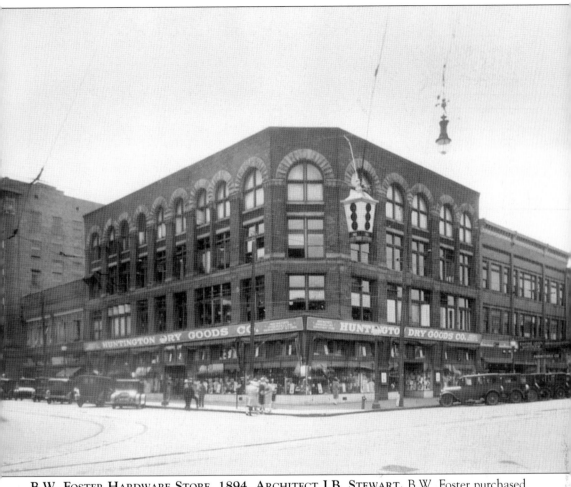

B.W. FOSTER HARDWARE STORE, 1894, ARCHITECT J.B. STEWART. B.W. Foster purchased this parcel of commercial property, located on the southwest corner of Ninth Street and Third Avenue, from the Central Land Company. In 1894 Foster built the four-story brick and stone structure in a Romanesque style with arches and stone banding to replace a wooden structure, which had occupied the site previously. He opened Foster Hardware and operated it until his death. In 1923 Walter Lewis purchased the property, renovated it, and connected to the adjacent three-story building that had been the Third Avenue Hotel. He then leased it to Meyer Mittenthal and M.J. Federman who established the Huntington Dry Goods Store. In the late 1950s Walter Lewis added the fourth floor to the former hotel section and excavated a basement under the whole building. He covered the original brick-and-stone exterior with a then-contemporary-looking enameled, panel façade, and he leased it to the Interstate Department Stores, which operated the building as the Huntington Store. In 1996 Lewis's heirs converted the ground floor to restaurants and made major restorations to the building. The upper floors are offices. The original exterior façade was uncovered and interior ceilings exposed. A lobby was built to give access to the upper levels on Ninth Street. The above photograph taken in the mid-1920s also reveals the former Vinson-Tompson tower to the left, which was later demolished.

HUNTINGTON HOTELS. The earliest recorded hotel in Cabell County was the Holderby Hotel, which once stood on Sixteenth Street and the Ohio River, starting around 1810. Stage passengers from the east and boat passengers from Cincinnati and Pittsburgh were often overnight guests. Other well-known hotels were the Carroll House in Guyandotte and Jacob Baumgardner Hotel in Barboursville. During this heyday many riverboats brought over 250 passengers upriver daily for shopping, business, and theater. The first hotel in Huntington was the Scrange Hotel; in 1871 it offered shelter to the early traveling salesmen and loggers. The city of Guyandotte had three hotels that were in operation prior, during, and after the Civil War—Buckey House, operated by Rodolphus Bucky; the Jacob Hiltburner Hotel, which later became the Crawley House, operated by Crawley Smith; and the Merchants Hotel, owned by W.H. Miller on Second Avenue and the corner of Ninth Street. From 1887 on, the Florentine Hotel, owned and operated by L.H. Cox, became the social center of the city. The Florentine offered a private men's club. W.W. Herring owned the Adelphi Hotel on the southeast corner of Sixth Avenue and Ninth Street. S.B. Greer owned the Wayne Hotel, located at 1116 Fourth Avenue. H.B. McWilliams owned the Hotel Bellevue at 848 Fourth Avenue. C.L. Hafner owned the Carrolton Hotel, on the east side of Ninth Street and Seventh Avenue. A.M. Thompson owned the St. Nicholas Hotel on the south side of Third Avenue near Tenth Street. (Florentine Hotel photo courtesy of Randal Brown.)

B&O RAILWAY PASSENGER STATION, BUILT 1887. The Ohio River Railroad built the B&O Railway Passenger Station, now owned by the Greater Huntington Park Board, in 1887, when it leased the Huntington and Big Sandy Railroad to extend its operations from Guyandotte to Kenova. In 1902 the B&O took control of the Ohio River Railroad by stock ownership and in 1902 the station was deeded to the B&O outright. The Cabell-Wayne Historical Society in 1967 began a 10-year restoration project of the passenger station and the freight houses. The historic "Heritage Village" opened in 1977, when the structures were adopted to modern retail uses. At one time the station served four passenger trains daily, including one set that ran between Pittsburgh and Cincinnati. The last sleeping car service ended in September 1952, and the last first-class passenger train left from the station on January 31, 1952. Notables who have stopped at the station include Presidents Theodore Roosevelt, Warren G. Harding, and Dwight D. Eisenhower.

BANK OF HUNTINGTON, BUILT IN 1875. The former Bank of Huntington was founded in 1872 and built in 1875. The bank later became the First Huntington National Bank and was incorporated into Heritage Village in 1977. It was once located on Third Avenue near the intersection of Tenth Street; the Cabell-Wayne Historical Society moved the building to its new location at Eleventh Street and Veterans Memorial Boulevard.

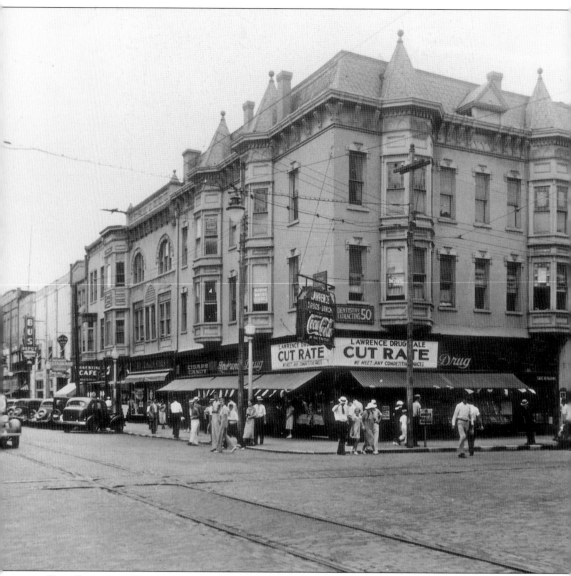

THE CALDWELL BUILDING, 1890–1895. Located on the northwest corner of Ninth Street and Fourth Avenue, the Caldwell Building's original façade was the adaptation of the French Academic School of the 19th century. Huntington's second post office was in the Caldwell Building in the late 1890s. The Caldwell building is a series of three individual structures. The largest section has an elaborate mansard French roof with turrets and chimneys covered in tile. Brackets support the ornate cornice in copper, while the bay windows have molded trim. The others smaller buildings to the left also have brackets and rusticated stone arches. The former trolley tracks, brick Georgian streets, and the early 1930s fashion and automobiles reflect an optimistic period.

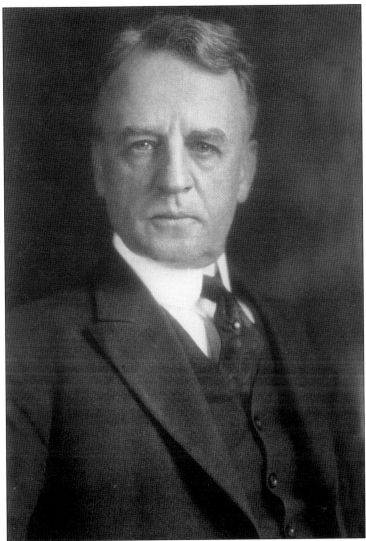

Dwight Whitney Morrow, Father of Anne Spencer Lindbergh. Dwight Whitney Morrow was the son of James E. Morrow, former president of Marshall College in Huntington. James attended Jefferson College and graduated in 1856. During the Civil War, he met Clara Johnson while she was winding bandages in Wheeling. In September of 1867 they were married, and in 1871 he accepted the post of president at Marshall College. Attached to this position was free lodging within the Old Main building on campus. It was in this small apartment on January 11, 1873, that Dwight Whitney Morrow was born. More than 50 years later, Dwight revisited the place of his birth in June of 1928; he was accorded an Honorary Degree at Marshall College. Dwight attended Amherst College from 1891 to 1895 and attended law school from 1896 to 1899. In 1901 he met Miss Simpson in New York and they were married on June 16, 1903, in Cleveland. From 1899 to 1914 Dwight worked as a corporation lawyer and in 1914 he accepted a post with J.P. Morgan & Company. From 1919 to 1921 Dwight was an active participant in the Coolidge for President campaign. In 1921 Dwight was offered the presidency of Yale University and refused; in 1927 he became Ambassador to Mexico. His daughter, Anne Spencer Morrow, was born June 22, 1906. She would join hands in marriage with Charles Augustus Lindbergh on May 27, 1929. Anne was one of four children.

Dr. R.E. Vickers Home, Built 1895, and Mt. Hope Hospital. In 1871, Dr. Vickers was one of Huntington's early doctors. His rusticated, romantic, sandstone and brick home of gothic Queen Anne structure reflects some of the early works of architect J.B. Stewart. The home was once located on the south side of Fifth Avenue between Ninth and Tenth Streets, where the Huntington Bank stands today. When the Huntington Hospital Association was formed in 1901, Dr. Vickers was one of its staunchest supporters. During the same period the women of Huntington had formed a hospital auxiliary and in 1902, a board of directors was formed. In 1910 Dr. Vickers opened Mt. Hope Hospital; later the hospital was incorporated by Dr. Vickers and associates and was located on Fourth Avenue just west of Fifth Street. (Mount Hope Hospital print courtesy of Randal Brown.)

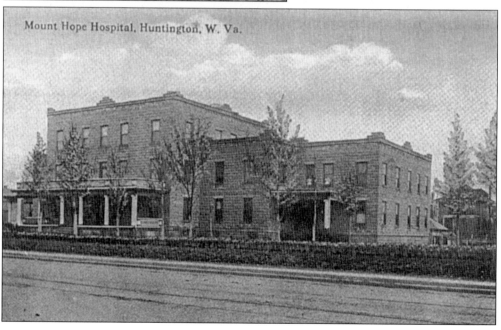

Mount Hope Hospital, Huntington, W. Va.

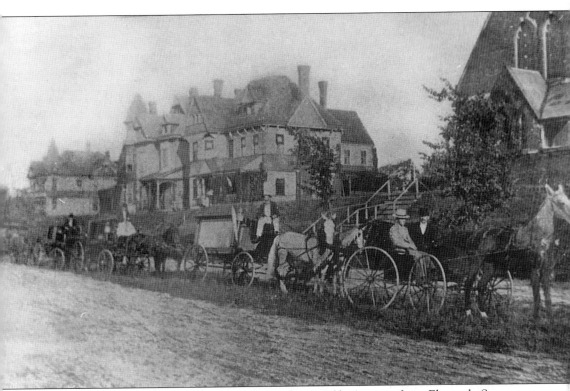

HISTORIC FIFTH AVENUE. Looking southeast down Fifth Avenue from Eleventh Street to Twelfth Street is the original entrance to Trinity Episcopal Church, built in 1884. Traveling west on Fifth Avenue is the R.F. Williamson Livery and Feed Stable Company. From the top left are five Queen Anne homes. Standing on the east side of Twelfth Street and Fifth Avenue was the Joseph R. Shelton home, built around 1885. Joseph R. Shelton, born in Nicholas County, came to Huntington in 1873 to attend Marshall College and resided in the home of L.C. Buffington. In 1881 he married Anna Poage, daughter of one of the oldest families in Cabell County. Upon his death in 1929 he left his wife and two sons, Harvey W. Shelton and Kemper Shelton. During his long life in Huntington, Shelton served as deputy sheriff under Maj. George McKendree and subsequently E. Kyle. For a quarter of a century the family was associated in the insurance and real estate business. The Shelton family were members of the Fifth Avenue Baptist Church and the Huntington Lodge No 313. Today the Fifth Avenue Baptist Church stands where the five former Queen Anne homes once were, and the Shelton property is now a parking lot.

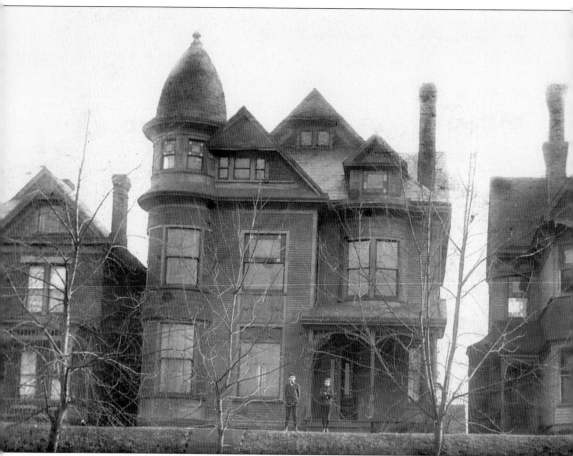

H.M. Adams Home, 1884. This three-story Queen Anne structure was built in 1884 by H.M. Adams; he and his wife are standing in front of their residence at 1121 Fifth Avenue. H.M. was one of Huntington's postmasters from 1889 to 1894. The post office was located in the Caldwell Building on the corner of Ninth Street and Fourth Avenue. In the developing city of Huntington on February 27, 1889, the state legislature passed an act that provided for a school board of six members whose term of office was three years. The first board elected included Sam Gidon, B.H. Thactston, R. Enslow, H.M. Adams, W.O. Wiatt, and H.C. Simms. On February 19, 1890, the *Herald* newspaper was organized and H.M. Adams was a stockholder. The Adams home once stood where the Fifth Avenue Baptist Church is located today.

CENTRAL CITY SPORTS TEAMS. The photograph above shows the Mountain State Baseball Team at Camden Park in 1908. The photograph below shows the Central City High School Basketball champions of 1923.

ELECTRICITY BY ERENST BARRIAS, 1890. From 1900 on, Huntington would experience the development of impressive and imposing private estates in the South Hills of the City. Thomas Edison's genius efforts with electricity had now taken on a new dimension that would forever alter the lives of Huntington residents and people all over the world. Some homes in Huntington now had electric lighting, and the city installed streetlights. The Arts and Crafts movement had begun in full force and was a dramatic response to the deterioration of quality and design of many machine-made products. This movement promoted traditional crafts and vernacular building practices and sought to introduce the direct relationship between the designer and the maker—exploiting the experience of the artisan and emphasizing the innate characteristic of natural materials.

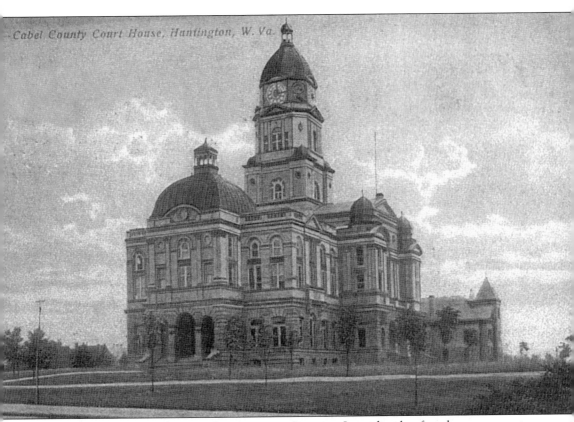

Cabel County Court House, Huntington, W. Va.

CABELL COUNTY COURTHOUSE, COURTHOUSE SQUARE. Immediately after the county seat was moved from Barboursville to Huntington, the question of the site for the new county buildings arose. The present location—historically named Block 90, the square between Fourth and Fifth Avenue and Seventh and Eighth Streets—was chosen. The location was opposed by a number of citizens on the grounds that the tract was too large; furthermore, it was too far from the business center. This opposition was overcome and the county court acquired Block 90 on July 29, 1892, at the price of $24,757. After acquisition of the Courthouse Square, the panic of 1893 came on and lasted until the turn of the century. It delayed the construction of the new courthouse. On May 8, 1895, the county court entered an order that the court would receive plans and specifications for the courthouse, to be of stone and brick, two stories high, slate roof, lighted with gas and electricity, heated by steam or air, and have three fronts and four entrances. It was to contain room for the circuit court, the county court, and the clerks' offices for each court, with fire-proof clerks offices or vaults attached, and range in cost from $60,000 to $100,000. It was required that such plans should be accompanied by bids and bonds guaranteeing that the building be erected at the estimated cost. On July 20,1895, a number of plans and specifications were received by the court, and the plans submitted by the well-known architects Gunn and Curtiss of Kansas City, Missouri, were accepted for a building constructed according to these plans and specifications for $96,000. In September an order was entered inviting bids for erection of the building and on October 11, 1895, a number of bids were received. The contract was awarded to Charles A. Moses of Chicago, Illinois, for the erection of the building at a cost $ 95,850. The Moses Construction Company was to put in the foundation at a price of $6,475, the work on the foundation to be done in the fall and winter of 1895. The impressive rusticated sandstone basement foundation was constructed before the end of the year under the superintendent of James L. Thornburg, the county surveyor, but no further work was then done on the courthouse. (Courtesy of Randal Brown Collection.)

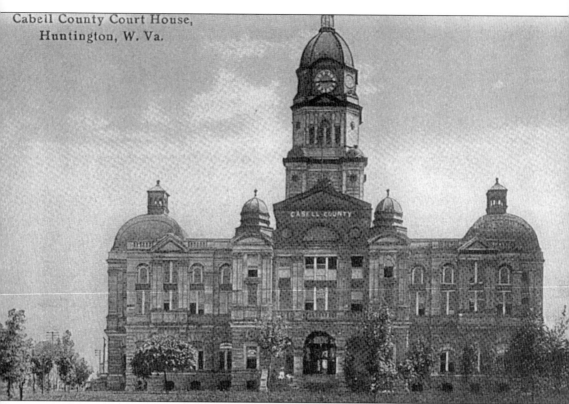

Cabell County Court House, Huntington, W. Va.

CORNERSTONE LAID AND TIME CAPSULE, NOVEMBER 11, 1899. On July 21, 1896, an order was entered requesting that Charles A. Moses appear before the court on the third Monday in November, prepared to enter into contract for the erection of the Cabell County Courthouse. On December 3, 1896, Charles A. Moses appeared in court with a contract dated November 24, 1895, which had been executed by himself, B.H. Thackston, and C.C. Dickey, commissioners, providing for the construction of the courthouse. This contract was approved but it contained the significant provision that the work was to begin in 1897 or 1898, after 60 days notice had been given to the contractor by the county court. The work was to be completed as rapidly as possible and paid for by the county orders out of the Levy of 1896. No work was done during 1897, 1898, or the early part of 1899, but in the summer or early fall of 1899 the work began on the new building. J.S. Suphart, a Belgian, was the superintendent in charge of erection. J.B. Stewart was supervising architect representing the county court. The celebration ceremonies were attended by the most important organizations of the city and county and all of the public officials as well as a vast number of citizens; the procession formed on the corner of Third Avenue and Ninth Street at 2:15 and marched to Courthouse Square. George S. Wallace was Grand Marshall of the parade. Hon. W.R. Thompson had been selected to deliver the oration, immediately following the ceremonies of the Grand Lodge.

DINNER AND SUPPER AT THE OLD POST OFFICE BUILDING. First-class oysters and ice cream and cake were on hand all day Saturday. It was an impressive scene at the new courthouse. The ceremony was a most interesting one and the pre-arranged program was carried out in every detail. When completed, the courthouse would be the handsomest in West Virginia. The new courthouse cost upwards of $100,000 and the selection of the style of architecture from the Renaissance school, as well as the conception of the interior and exterior arrangements, reflected much credit upon the architects, Gunn and Curtiss. The building proper was 150 by 90 feet and on the first floor was the county clerk's room, which was 42 by 26 feet. The county court was 86 by 23 feet and the committee room was 28 by 18 feet. The second floor contained the circuit court room, which was 58 by 40 feet and had 26-foot ceilings, and the criminal court room, which was 40 by 60 feet. The third floor contained jury rooms and apartments for witnesses. All of the stairways had marble wainscoting four feet high and the hallways and corridors were inlaid with mosaic work. The material for the building was sandstone taken from the Berea and Amhurst, Ohio quarries. For two years the new courthouse was under construction. The basement was one of the largest in the entire country, covering all the space beneath the first floor and paved with cement. The workmanship of A.E. Suphart of Chicago and C.A. Moses was superb. During A.E. Suphart's stay in Huntington, he won a host of friends. Mr. Suphart identified himself with the community and continued to work in West Virginia as a construction man.

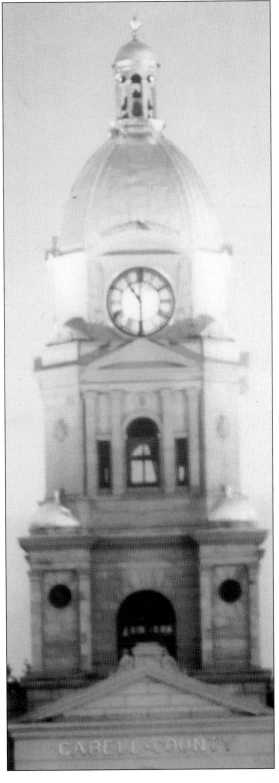

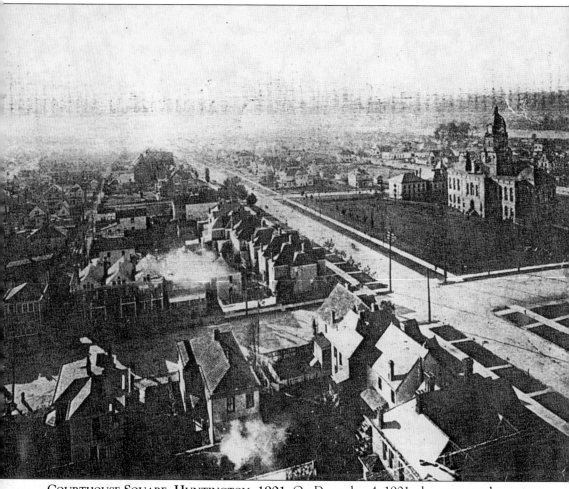

COURTHOUSE SQUARE, HUNTINGTON, 1901. On December 4, 1901, the new courthouse was completed and the county court entered an order declaring the structure ready for occupancy. After the completion of this new courthouse, the people of Cabell County and particularly of the city of Huntington were pleased with and proud of the new structure and felt that they had provided for the needs of the county for a long time to come. On October 8, 1901, a contract with Howard Clock of Boston closed for a town clock at the cost of $1,200; the clock was to be running in 60 days. Over 100 years ago, Huntington reflected all the hopes of a planned community. Above is a view of Fifth Avenue and Eighth Street looking west, showing the residential view of the city of Huntington and the Cabell County Courthouse and new jail on the west side. Today, city hall sits on the northeast corner and the Dwight D. Eisenhower Building stands on the southeast corner; a gas station now occupies the southwest corner. One of the Ritter families once occupied the home across from the county jail between Fourth and Fifth Avenues and Seventh Street.

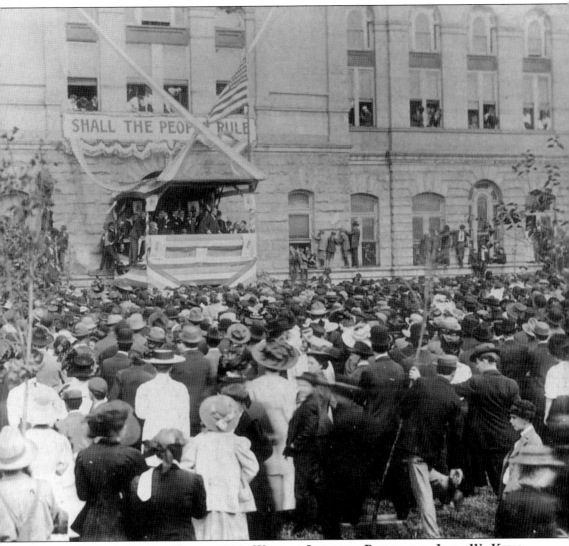

CABELL COUNTY COURT HOUSE 1908, WILLIAM JENNINGS BRYAN AND JOHN W. KERN, CANDIDATES FOR PRESIDENT AND VICE-PRESIDENT. This rare photograph shows William Jennings Bryan and John W. Kern campaigning on the Fifth Avenue side of the Cabell County Courthouse. On November 4, 1908, William H. Taft and James S. Sherman defeated William Jennings Bryan and John Kern in the presidential election.

EDWIN N. ALGER, ARCHITECT. Edwin N. Alger, one of the best-known architects in the state, arrived in Huntington in July 1901. Alger was born in Mansfield, Ohio, on October 8, 1870. The son of Capt. A.H. and Julia Wharton Alger, he followed his father's example in entering an architectural career, as did his two brothers. The Alger family moved to Portsmouth, Ohio, when Edwin was three years old; he spent his childhood in that city. On June 5, 1902, Alger married Kate Numan of Portsmouth; their one daughter was Clay Moore Alger. Another child, Nedman Alger, died in 1911, when he was eight years old. Edwin N. Alger worked in Huntington for the firm of James B. Stewart until the completion of the Frederick Hotel in 1906. In 1907 Alger opened his own office, and within a few months, the business was thriving. He later became the father of residential design and the principle architect of Huntington's Fifth Avenue homes from Twelfth Street East to Eighteenth Street East. Alger designed and built the Vinson-Thompson office building, which was the city's first skyscraper, and the First Congressional Church on Fifth Avenue and Seventh Street East in 1911.

CARNEGIE LIBRARY, 1901–1902, ARCHITECTS J.B. STEWART AND EDWIN N. ALGER. Cabell County's first main library, located on the northeast corner of Ninth Street and Fifth Avenue, was the Carnegie Library. An outstanding example of the Beaux Arts Classicism, it was constructed in 1901–1902 and is listed on the National Register of Historic Places. In 1901, industrialist and philanthropist Andrew Carnegie offered the city of Huntington funds for the construction of the library, and it was the chief reason that architect J.B. Stewart brought new architect Edwin N. Alger and his talent to Huntington. The Carnegie Library is a sandstone edifice with terra cotta ornamentation in the crown cornice of the front and side. The front temple entrance has four Ionic two-story columns supporting the extended eaves. The cornice banding bears the names of noted literary scholars, such as Socrates, Shakespeare, and others. On the west side of the edifice on the Ninth Street Plaza stands the sculpture titled *Continuous Ascent*. John Rietta designed the sculpture in 1979; it is constructed of a high nickel alloy and donated and fabricated by the Huntington Alloy Inc. The base was donated by Neighborgall Construction Company.

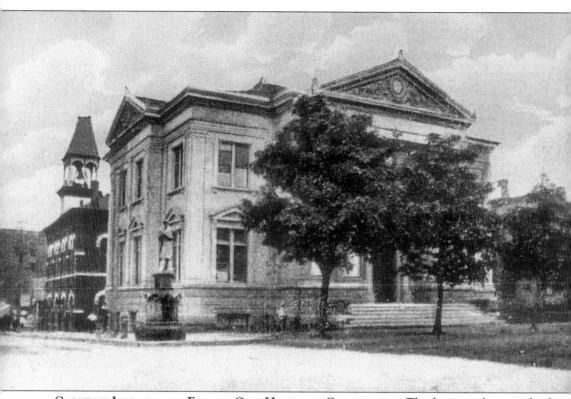

CARNEGIE LIBRARY AND FORMER CITY HALL AND COURTHOUSE. This historic photograph of the Carnegie Library also reveals the old city hall and Huntington's first temporary courthouse with its bell tower and its arched windows, located just north of the library. Standing in front of the library was the only monument and water fountain in memory of the Civil War Soldiers from Cabell County. Today, a fire hydrant stands where the graceful fountain once stood.

GUYANDOT CLUB, 1904, ARCHITECTS J.B. STEWART AND EDWIN N. ALGER. One of Huntington's earliest men's clubs was the Irving Club, which was organized by Ely Ensign, John Hooe Rudssel, and Henry C. Simms in the late 1880s. In 1903 the Guyandot Club was incorporated and became the successor of the Irving Club. Architects J.B. Stewart and Edwin N. Alger designed the club's fashionable home on the southeast corner of Eleventh Street and Fourth Avenue. The club would remain in this structure until 1945; after the building suffered through the 1913 and 1937 floods and the Great Depression it was torn down and the club moved to the Frederick Hotel.

GUYANDOT CLUB, HUNTINGTON, OCTOBER 7, 1904. The object of the club meeting was for the purpose of discussing the advisability of bonding the club property for the sum sufficient to complete and furnish the new building. Membership at that time numbered 135. Total expenses were estimated to be $3,850 for the cost of the real estate, $15,000 for the building, and $3,000 to furnish the building, for a total of $21,850.

MEMBERS OF THE GUYANDOT CLUB 1904

R.H. Armstrong
R.L. Archer
D.E. Abbott
S.S. Altizer
Chas. W. Blair
Homer Bell
E.S. Buffington
R.M. Baker
M.E. Brown
Mike Broah
J. Broah
H.W. Bloss
H.O. Boette
T.J. Bryan
Jas.J. Brady
Geo.N. Biggs
C.C. Beeber
H.G. Bowles
L.J. Corbly
H.A. Carder
L.X. Cox
R.M. Clouston
J.L. Caldwell
C.W. Campbell
Chas.F. Cole
D.P. Carder
C.W. Cammack
W.K. Cowden
J.C. Carter
W.O. Dicky
Paul Dober
H.C. Duncan
Earl D. Dudding
E.S. Doolittle
F.L. Dollittle
Walter Davis
E.B. Enslow
F.B. Enslow
C.R. Enslow
A.S. Emmons
J.A. Emmoms
C.D. Emmons
J.W. Ensign
Herbert Fitzpatrick
F.D. Fuller
Jas.Fagan
J.J. Fesenmeier
C.H. Freeman

J.R. Gallick
D.B. Gwinn
W.W. Gwinn
C.E. Gwinn
C.M. Gohen
H.C. Gordon
John Graham
A.L. Gregory
Dave Gordon
Wm. H. Gideon
G.H. Honshell
J.M. Hawkins
C.W. Hunter
H.C. Harvey
Tos. H. Harvey
I.J. Harsbargr
Jno H. Holt
A.A. Hanley
H.B. Hagen
C.C. Hogg
Jas. H. Hughes
J.L. Hawkins
V.L. Hagy
W.H.H. Holswade
W.E. Hunter
W.F. Hite
W.J. Harvie
R.L. Hutchinson
Irvin Hartzell
Tos. Mck. Hays
L.D. Isbell
Geo. P. Ingram
Jno. A. Jones
J.J. Kearney
H.T. Lovett
J.H. Long
J.C. Miller
Geo. F. Miller
Jno. L. Marr
T.W. Moore
C.R. Moriarity
L. Merrill
E.P. Merrill
Geo. J. McComas
H.C. McMillen
J.M. McCoach
F.F. McCullough
Geo. Mc Kendrie

Elliot Nortcott
G.A. Northcott
Jeff Newberry
Chas. Nash
S.H. Nigh
Ge. I. Neal
R.L. O'Neal
Jno. Olson
J.K. Oney
R.S. Prindle
B.L. Priddle
T.J. Prichard
T.W. Payton
B. Pratte
C.L. Ritter
P.A.Rutledge
J.E. Rice
J.F. Ratcliff
Rufus Switzer
J.B. Steveson
J.B. Stewart
P.W. Scott
H.C. Solter
H.C. Simms
A.F. Southworth
T.S. Scanlon
Wm. Siber
W.R. Thompson
C.T. Taylor
C.L. Thompson
Thoas. Tinsley
J.W. Taylor
J.W. Valentine
W.S. Vinson
E.C. Van Vleck
Z.T. Vinson
R.E. Vickers
C.W. Watts
E.E. Williams
W.O. Walton
C.R. Wyatt
C.M. Wallace
F.A. Ware
Herman R. Wild
A.W. Werninger
J.W. Winget
Geo S. Wallace
Warren Wood

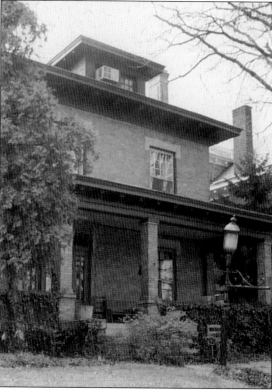

MAYOR GEORGE I. NEAL. Born in Milton on March 3, 1868, Neal attended the Milton school and taught for a brief period. He later attended West Virginia University and received a degree in law. He was admitted to the bar of West Virginia on December 3, 1888. The First National Guard Company organized in Huntington was in 1889; George I. Neal was first sergeant. His extraordinary future would rest in him becoming one of the most dominant political powers in the city of Huntington and Cabell County. In 1893 Neal was elected mayor and served two terms during one of the most turbulent financial periods of the nation. The Cleveland Panic had a profound effect on the city of Huntington; unemployment became a driving force and changed the entire county to Republicans in 1894. George I. Neal won a hard fight for the Democratic nomination for Congress in 1894. He was one of the early presidents of the chamber of commerce and helped shape all of the important programs in the city's development. He was very active in 1909 in bringing about the commission form of government for Huntington. He was unsuccessful as a Democratic candidate for Congress in 1914. George served many years on the Democratic State Committee. Later he would become the United States Attorney for the Southern District of West Virginia. Resting on an embankment and located at 447 Fifth Avenue, George I. Neal's home was architect Edwin N. Alger's first Edwardian Arts & Crafts style home in Huntington. It was built in 1902 and is one of the few remaining homes of the period that is almost intact. The handsome brick structure has stone lentils over the windows and the front door entrance is an academic expression of leaded crystal with sidelight leaded windows.

LAURA PAULINE HARRIS BUFFINGTON AND PETER CLINE BUFFINGTON II.

Laura Pauline Harris was the daughter of Dr. Hugh Harris of Athens, Georgia; the granddaughter of Judge Samson W. Harris of Alabama; and the grand-niece of William L. Yancy; a Confederate statesman. She married Peter Cline Buffington II on November 21, 1895. Peter Cline Buffington II was born August 6, 1868, at what was once Forest Hill Plantation. His father, Peter Cline Buffington I, was the first mayor of Huntington, and his mother was Louisa Garland Buffington. Peter was educated at Marshall Academy and at Randolph Macon College. In 1889 Peter Cline Buffington was associated with G.A. Northcott in the clothing firm of Northcott & Buffington. Later he served one term in the state legislature and served as sheriff of Cabell County from 1912 to 1916. He was also engaged in an insurance business that would later become the Staats-Blair Insurance Agency. For the historical record, Pauline Harris Buffington discovered in her research in an old English Bible that the Cline spelling in the Buffington name was originally Clyne.

CHARLES LLOYD RITTER, 1897. Charles Lloyd Ritter, lumberman, banker, and capitalist, was born in Lycoming County, Pennsylvania, in 1865. Charles was the son of Daniel S. and Catherine Kramer Ritter. Educated in public schools of Williamsport and Muncy, Pennsylvania, Ritter came to West Virginia in 1889 and first located at Oakvale, where he was engaged in the lumber business. Ritter and his business later moved to Welch and then Charleston, West Virginia, before finally setting up in Huntington in 1897. In 1902 Charles married Mabel McClintock of Huntington. He was a director of the First Huntington National Bank, president of the C.L. Ritter Lumber Company, president of the Central Reality Company, president of the Huntington Land Company, vice-president of the Watts-Ritter Company, president of the Kenova Land Company, president of the Norfolk Land Company, and president of the Kentucky Rock Castle and Eastern Company, the concern operating the railroads in Kentucky running to his coal mines. Mr. Ritter came to West Virginia with a humble beginning, accumulated a fortune, and won the confidence of all who knew him. He was known for his generosity and often lent money to individuals in need. In 1932 the City of Huntington faced the grim reality that it was bankrupt and could not pay the policemen or the firemen on the city's payroll. Charles L. Ritter was escorted by the police to city hall where he personally took over the payroll of the fireman and policemen and wrote them personal checks from his own account.

MABEL MCCLINTOCK RITTER. Mabel Ritter was the daughter of the late Charles A. and Adeline Richy McClintock; she was born May 9, 1880, in Dempsytown, Pennsylvania. She came to Huntington with her parents as a child and was educated in the public schools of the city, graduating from high school in 1898 and from Marshall College in 1900. After graduation she taught at Marshall. In 1902, Mabel married Charles Lloyd Ritter, one of the leading lumberman and financiers of West Virginia. Mabel was a life member of the Woman's Club of Huntington; a past Regent of the Buford Chapter, Daughters of the American Revolution; member of the Colonial Dames; and former state president of the West Virginia Garden Club, which she founded in 1928. She was an active member of the First Presbyterian Church. Mrs. Ritter was the founder of the Debutante Club of Huntington and was its sponsor for its Assembly Balls during the several years of its existence. Her family, the McClintocks, have been closely tied to Cabell County since 1889.

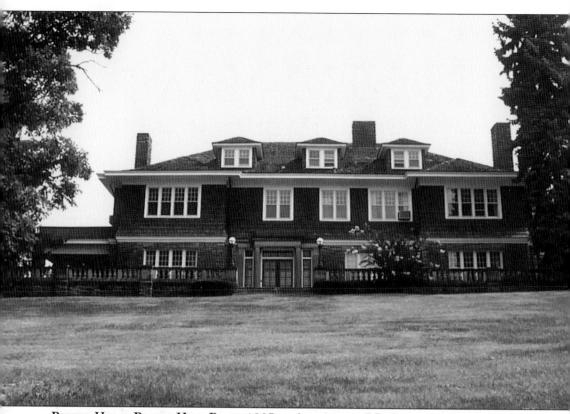

RITTER HOME, RITTER HILL, BUILT 1907 BY ARCHITECTS J.B. STEWART, EDWIN N. ALGER, AND VERUS T. RITTER. Charles Lloyd and Mabel Ritter began building one of the largest mansions in the city of Huntington in 1907. The original master plans for the imposing Arts & Crafts mansion were designed by James B. Stewart, who unfortunately passed away in 1908 at the age of 46. Edwin N. Alger assumed the responsibilities of the master plan until the arrival of C.L. Ritter's cousin, architect Verus T. Ritter. This grand edifice displays a one-story rusticated stone foundation, which was quarried on sight. The second story is shingled with an extended balcony on the left side; a series of dormers project from the third floor. The interior of the home was dressed in the finest oak wood of various hues; a terrace with a stone balustrade and spindles extend out from the front entrance. A carriage house and stables are located in the rear. The Ritter home has 27 rooms, including a vast center hall reception area with wood paneling connecting the drawing room, dining room, and library. There are nine bedrooms and five baths on the second floor, and six bedrooms and one-and-a-half baths on the third floor. The guest cottage has a large living room, two bedrooms, and two baths. The three-car garage has a three-bedroom servants quarters and a 12-by-26 foot green house grape harbor, flowers, and vegetable garden. The land includes 25 apple and pear trees. A few years after Charles Lloyd Ritter's death, Mabel wanted to move to a less spacious residence nearer the heart of the city. Mabel sold her palatial Park Hills mansion to the Pallontine Missionary Sisters, who operate St. Mary's hospital for a fraction of it actual value. The 27-room mansion, guest cottage, and a four-story barn and stable served as a convent to the "Pallontine Order of Nuns" for 20 years from 1951 to 1971.

Seven

HISTORIC HOMES AND PUBLIC BUILDINGS

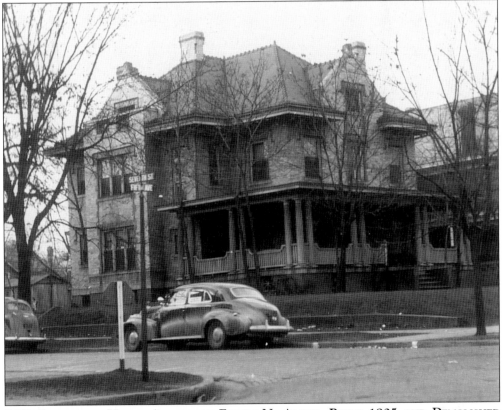

S.W. PATTERSON HOME, ARCHITECT EDWIN N. ALGER, BUILT 1905 AND DEMOLISHED 1961. This home was once located on the southwest corner of Fifth Avenue and Seventh Street, where WSAZ Television station Channel 3 is located today. This imposing three-story Edwardian home had an ornate verandah of classical columns and balustrades that supported an extended roof with brackets. The main roof was terra cotta tile. A Flemish style brick dormer divides the front central gable. All of the windows have stone lentils and seals. The third-floor gable facing Seventh Street has a balcony. The home had a full basement. The Patterson family were stockholders in the Consolidated Light & Power Electric Company. In 1946, the Adams family purchased the impressive mansion; Mrs. Adams later sold the home in 1953 to Mr. W.L. Rupe, who converted the residence to a nursing home. The impressive structure was demolished in November of 1961.

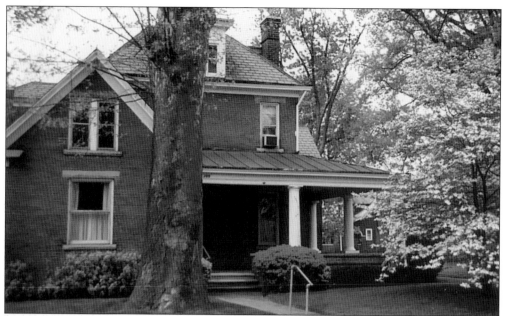

HOWELL-BARLOW-SMITH HOME, 1905. This pleasant Queen Anne Edwardian structure, located on Sixth Avenue and Third Street West, was built of red brick around 1905 by Mr. L.E. Howell, who owned a successful brick plant located on four Pole Creek and Tenth Street West. The property was later purchased on January 19, 1914, by Joseph E. Barlow, a mining engineer and owner of a coal company in Logan, West Virginia. Mr. Andrew Barlow, his sister Anna C. Smith, and her husband presently occupy the home.

POLLARD-JOHNSTON HOME, 1900–1901. Located at 217 Ninth Avenue between Second and Third Street West stands the former Pollard-Johnston home. On August 22, 1892, F.C. Pollard purchased several lots from Augustus C. Masters and created the Johnston subdivision. John C. Pollard conveyed the property to Mary J. Johnston on July 22, 1893. The Johnston subdivision property sold seven lots in 1900 to John Fullen through their building and loan association. This restored structure belongs today to Kevin Madson and Rick A. Eaton.

PARSONS HOME, BUILT 1899–1900, DEMOLISHED 1964. Once located at 1639 Sixth Avenue, the Parsons home was demolished in 1964 to make way for a new Sigma Sigma Sigma Sorority House. The Parsons farm and home was built in 1899–1900 and the city's old timers remember that the house was once surrounded by farmland with a large swimming pond near the house. The red brick structure reflects the later Queen Anne-Edwardian period.

BEUHRING HAWKINS HOME, 1901, ARCHITECT J B. STEWART. The former Beuhring Hawkins home still stands on the southwest corner of Sixth Avenue and Fifteenth Street. Construction began in 1900 and was completed in 1901. This charming Edwardian home has a Gothic turret and several gables projecting from the second floor. The porch wraps the structure with Ionic columns and spindled balustrades. All of the windows have rusticated stone sills and lintels. The Beuhring family were early settlers of Cabell County. Their former plantation, known as Maple Grove, once extended from the Ohio River between Seventh and Eleventh Streets to the foothills of Ritter Park. The former mansion on the Ohio River was the office for Collis P. Huntington. Virginia Eleanor Beuhring married John Hawkins and had five children.

JOHN A. RAU JR. HOME, 1901–1902, ARCHITECT J.B. STEWART. Standing at 735 Fifth Avenue is another Queen Anne structure. John A. Rau Jr. and family occupied most of the homes from the corner of Eighth Street to the center of the block. John had one of the finest barbershops in the old Florentine Hotel in Huntington until the new and impressive Frederick Hotel was completed; John A. Rau Jr., G.A. Northcott, and J.C. Carter opened the first business in the gleaming Frederick Hotel in 1906. Today the Rau home is occupied by a law firm.

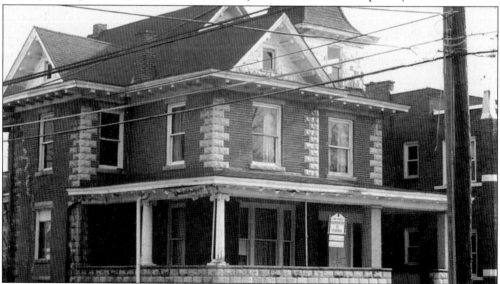

JOSEPH M. VEST HOME, 1901–1902, ARCHITECT J.B. STEWART. The former Joseph M. Vest home is located at 522 Seventh Street East. Vest was president and manager of Alemma Coal Company; his wife Faye Vest was in the commercial travel business. A sister of Joseph, Maude Vest also resided in the home. She was a professional secretary.

EDMOND VALENTINE JOHNSTON AND ESTELLE YORK JOHNSTON HOME, BUILT 1905 AND DEMOLISHED IN 2001. Located at 1144 Sixth Avenue and the northwest corner of Twelfth Street was this late Queen Anne home with a tile roof and two dormers supporting fan light windows. The classical column porch once wrapped the structure and included the French doors to the living room. The Twelfth Street entrance leads into an entrance hall with a bay window. A two-story room supports a stair well with an exceptional oak staircase. The fireplaces are oak with Rookwood tile facings. The home has nine rooms, with a sun porch and garage that was added in the early 1920s. Owned for many years by the Johnston family, the home was occupied by the author in 1997. Later the home was donated to the Fifth Avenue Baptist Church by the former owners and demolished in 2001.

ALESHIRE HOME, BUILT 1905–1906. Once located at 1143 Sixth Avenue on the southwest corner of Twelfth Street was the H. O. Aleshire home. The two-story structure's stone porch entrance faced Twelfth Street; on the second floor are arched windows and a small balcony facing Sixth Avenue.

THOMAS M. CARR & ALICE CARR HOME, BUILT 1908. Located at 1208 Sixth Avenue and near the northwest corner of Twelfth Street is another fine example of the Edwardian eclectic style of architecture. This three-story brick structure rests upon a rusticated stone foundation with three Ionic columns supporting the porch. Above, a balcony extends from the second floor with a large bracket supporting the ornate wood cornice that wraps the structure; right above is a subtle dormer next to a pronounced gable with the repeated cornice. Black shutters flank all the windows. Mr. and Mrs. Carr had a daughter, Lola B. Carr, who was a musician. The Carr family dates back in Cabell County to 1838, when Benjamin Carr married Harriet Rice.

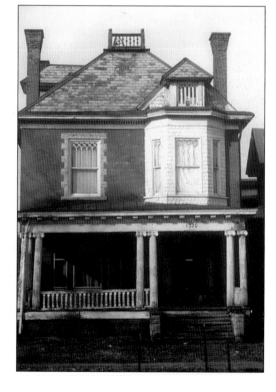

EDWARD L. FULTON HOME, BUILT 1903–1904. Located at 1320 Fifth Avenue is another exceptional example of Edwardian Queen Anne architecture. This three-story red brick structure with a slate roof is crowned with a fenced copula and fan shaped chimneys. A dormer projects from the third floor gable that rest above a shingled bay window. Dentil block trim is apparent beneath the second story cornice, and rusticated stone wraps the one single window. The dramatic Queen Anne–front porch rest upon a rusticated stone foundation with paired fluted ionic columns supporting the roof with its extended brackets and the repeated dentilblock trim. A spindled banister wraps the porch. Edward L. Fulton was a miller at Gwinn Brothers & Company in 1910.

GEORGE SELDEN AND FRANCIS B. WALLACE HOME, BUILT 1904–1905. Located at 1520 Fifth Avenue this Edwardian Queen Anne structure has a rusticated stone foundation with an elliptical porch. George S. Wallace was born in 1871 in Greenwood, Virginia. He came to Huntington in 1893 as a dispatcher for the C&O Railroad. He served in the Second West Virginia U.S. volunteer infantry. In 1901 he was appointed major, and in 1905 he married Francis Bodine Gibson. He and Francis had five children. In 1917 Wallace was appointed Draft Executive for the State of West Virginia. Ordered on to duty as a major, he was later appointed lieutenant colonel and ordered to the headquarters of the American and European Forces in France where he served as senior assistant to the Judge Advocate General for France until 1919.

WILLIAM AND ROBERTA ULLMAN HOME, BUILT 1906–1907. Located today at 1544 Fifth Avenue this double lot was purchased by Bertice C. Ullman on November 17, 1903, from I.E. Gates. William Ullman was the president of The West Virginia Stove and Foundry Company, which his family founded in 1901. This Edwardian eclectic brick structure has a concrete foundation; the elliptical porch has rusticated stone columns. The elaborate roof has an oriental flair that supports two imposing fanned chimneys.

EDWARD W. AND ANNA STEWART CHASE HOME, BUILT 1904–1905. Edward W. Chase and his wife Anna Stewart Chase purchased property in 1903 from I.E. Gates and built this handsome three-story, Edwardian brick home. Edward Chase had a stationary and book store at 324 Ninth Street. In 1907 C.L Thompson purchased the property, and later sold it to Beulah Burns in 1921. The squared front columns on the porch were once fluted Ionic columns. The rusticated stone arch window with a central bracket mount and the ornate metal trim on the Flemish style front gable is typical of the Edwardian period. Dr. Carl K. Finch and his wife Nina C. Finch purchased the 21-room home in 1952 and raised their family in the home.

COLONEL AND SALLY MILLER HOME, BUILT 1904–1905, ARCHITECT EDWIN N. ALGER. The Miller home at 1508 Fifth Avenue is one of the earliest homes to be built on the north side of Fifth Avenue between Fifteenth Street and Hal Greer Boulevard. The structure represents the finest elements of the Edwardian age with the fluted classical Ionic columns supporting the porch and the porte-cochere on the west side of the structure. The Miller home has 15 rooms, with 6 rooms on the first floor, 5 rooms on the second floor, and 4 rooms on the third floor. The structure rests upon a full basement and a rear screened porch looks back to the two-car garage. The Miller family were part-owners of a bank and Miller Supply Company. Later the home was conveyed to Kattie Porter on August 14, 1939.

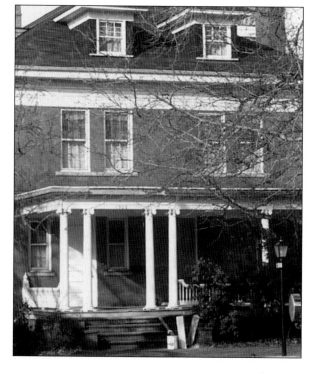

HENRY C. WATTERS HOME, BUILT 1901–1902. Once located at 717 Fifth Avenue across from the Cabell County Courthouse, this red brick two and one–half-story Queen Anne structure has ionic columns, spindled balustrades, and stone caps on the windows. A series of brackets supports the shingled gables above with a decorative window. The ceilings were plaster and the roof was slate. The home had eight rooms, two baths, and a two-story concrete garage with an apartment above. In 1925 the property was leased to the City of Huntington to be used for a baby clinic for a term of three years. Henry C. Watters was married to Mary Sophia Kyle.

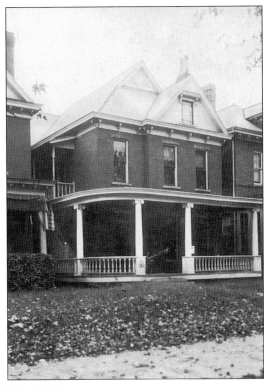

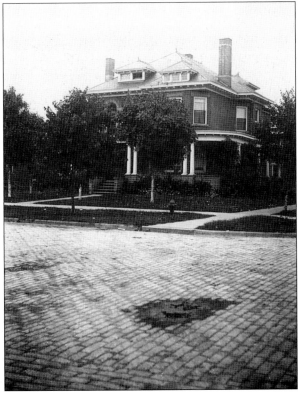

WALTER A. WOOD AND MATILDA R. WOOD HOME, BUILT 1904. An exceptional example of Edwardian architecture with total Edwardian interiors still stands at 1536 Fifth Avenue on the northwest corner of Fourteenth Street. This early photograph was taken in 1914 and shows that the existing elliptical verandah once had paired Ionic columns The home sits on a rusticated foundation and porch. There is a stone arch window on the second floor; above, brackets support the roof cornice; above, two dormers extend from the roof. This former 12-room mansion was first-class in its construction, with oak interior finishes and tiled mosaic Edwardian baths. This was considered a beautiful piece of architecture and situated in a desirable residential district. The home has been divided into apartments for Marshall University.

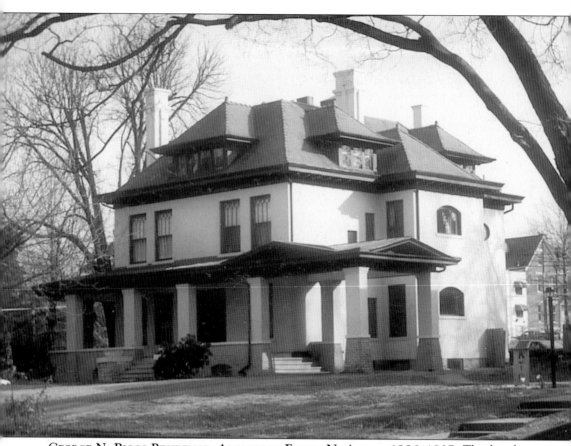

George N. Biggs Residence, Architect Edwin N. Alger, 1906–1907. This handsome Italian revival villa is located on the southwest corner of Fifth Avenue and Fifteenth Street. The structure has a tile roof with a series of decorative dormers and impressive chimneys with detailed decorative brickwork. The second-story front windows are leaded; the porte-cochere and the verandah with squared brick columns wrap the structure. The entrance hall is two stories and supports an impressive Edwardian staircase. In 1875 George N. Biggs and his brother-in-law Dr. A.J. Beardsley operated one of the largest mills in the state on the south side of Fourth Avenue between Ninth and Tenth Streets, where the Keith Albee Theater is located today. In 1912, Col. George S. Wallace made a contract with George N. Biggs under the terms of which Mr. Biggs agreed to furnish a lot fronting Fifth Avenue on the south side between First and Second Streets and $18,000 in money to be used in construction of an armory. Biggs would rent the premise to the State of West Virginia for $2,500 per year and at the end of a 10-year period the State would have the right to purchase the lot and the building at the price of $25,000. In 1921 the State of West Virginia purchased the property for $33,000 from the Biggs family. The armory is now gone.

THOMAS A. MARSHALL HOME, ARCHITECT EDWIN N. ALGER, BUILT 1909–1910. Located on the southeast corner of Fifth Avenue and Fifteenth Street, this imposing Arts & Crafts Tudor style structure has a pronounced tile roof with a central dormer and large brackets under the second-story cornice. The projecting two-story central bay supports part of the entrance hall staircase. Thomas A. Marshall and John B. Marshall were in the real estate business in 1910; their offices were located at 917 Fourth Avenue in Huntington.

JOHN LOWERY HOME, ARCHITECT EDWIN N. ALGER, BUILT 1907. Located at 534 Fifth Avenue is one of the finest examples of Edwardian Arts & Crafts style of architecture. This red brick structure has a front gable that is supported by large brackets, which are repeated under the roofline of the porch. The porch wraps the structure and is held up by fluted Greek Ionic columns. The chimneys are one of Alger's hallmarks with their decorative brick detailing. Today the home is used as the offices of Paul E. Campbell, Certified Public Accountant.

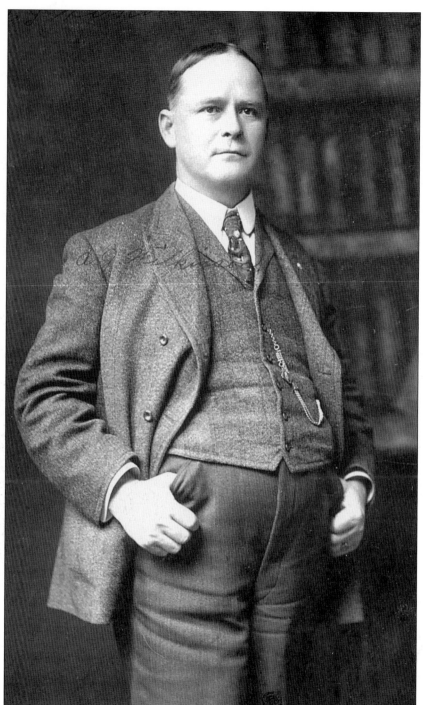

ASHBY JACKSON WILKENSON. Ashby Jackson Wilkenson was the founder and president of the Huntington Federal Savings & Loan. He was born on January 9, 1863, and died March 20, 1952. In 1909 A.J. Wilkenson and his wife Lulla Z. Wilkenson commissioned architect H. Rus Warne of Charleston, West Virginia, to design a unique and impressive 17-room Romanesque mansion at 1402 Fifth Avenue.

A.J. Wilkenson and Lulla Wilkenson and Their Daughter Mary Francis. The Wilkensons are photographed with their young daughter on the classical portico on a cold winter day.

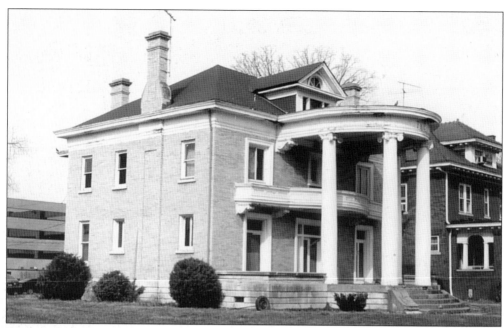

WILKENSON HOME, ARCHITECT H. RUS WARNIE, BUILT 1909–1910. The Wilkenson mansion was located at 1402 Fifth Avenue. H. Rus Warnie designed only three private homes in Huntington. As was the case with all great homes and mansions near Marshall University, this one would eventually would become a fraternity or sorority house. The Wilkenson mansion became home to Tau Kappa Epsilon fraternity and was eventually demolished. Resting on a one-story stone terrace and front entrance was a classical Romanesque style, three-story tan brick structure. The round front two-story portico had four two-story columns with ionic capitals. Above on the second-story is a Roman balcony with large acanthus leaf brackets supporting the rare round portico. Also pairs of acanthus leaf brackets flank the main entrance and support the balcony. The ornate round crown molding of the portico wraps the brick structure.

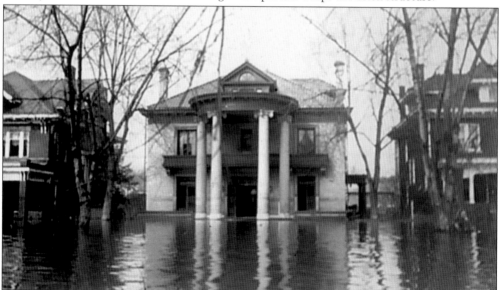

WILKENSON HOME. This photograph captures the Wilkenson Home during the 1913 flood.

COL. ZACHERY TAYLOR VINSON HOME, BUILT 1908, ARCHITECT R. RUS WARNE.
Originally located at 1429 Fifth Avenue in Huntington, this impressive Georgian structure had
19 rooms with extensive use of fine imported mahogany woodwork and elaborate use of stained
glass windows. The front entrance is a classical portico with four two-story Ionic fluted columns
supporting an entablature of impressive dentil block trim. There were only three homes in
Huntington that R. Rus Warne designed; only one remains. This charming and graceful home
remained in the Vinson family until 1969, when it was sold to the Phi Mu Sorority. The grand
structure mysteriously burned in 1980. Zachary Taylor Vinson was a prominent Huntington
attorney for nearly 45 years. Admitted to the bar in 1886, Taylor became senior partner in the
firm Vinson & Thompson. In 1890 Taylor Vinson launched himself into the railroad building
by securing from the City of Huntington a franchise for the Huntington & Big Sandy Railroad
Company and the Ohio River Railroad Company. These two trains connected a line by 1892
between Guyandotte and Kenova. Several years later he organized the Ohio Valley Electric
Company in 1903; this was the first interurban rail service between Huntington and Ashland,
Kentucky. In 1902 he convinced the United States Coal & Oil Company to acquire the stock
of the Island Creek Coal Company, which owned 30,000 acres of Southern West Virginia coal
land. That same year Vinson was elected to the United States Coal & Oil's Board of Directors.
Taylor married Mary Blair Chaffin in 1901.

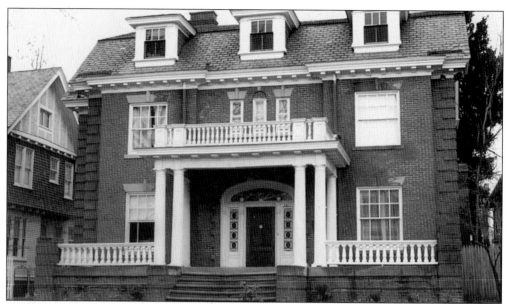

DANIEL HOLTON HOME, ARCHITECT EDWIN N. ALGER, BUILT 1909–1910. Located at 1411 Fifth Avenue this classical red brick Georgian structure with dormers on the front façade has a central porch with fluted Ionic columns an ornate balustrades on the porch level. The second-story cornice and porch have extended brackets. The front windows had stone caps and a central keystone. Daniel Holton worked for the Miller Supply Company in 1910

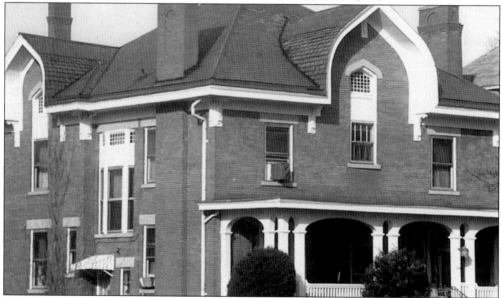

D.B. GWINN HOME, ARCHITECT EDWIN N. ALGER, BUILT 1909–1910. Located on the north side of Fifth Avenue between Fifteenth and Sixteenth Streets, this masonry, red brick structure is unique in its roof design. A series of Tudor arches grace the roofline. In 1889 the Gwinn family moved from Glenwood, West Virginia, to Huntington and built what was then a modern roller mill that produced flour, meal, and feed. Gwinn Brothers & Company produced over 5,000 barrels a day and employed 50 people. D.B. Gwinn was president of the company and the products were distributed in five states.

CHARLES RUSSELL WYATT SR. HOME, ARCHITECT EDWIN N. ALGER, BUILT 1906. Charles Russell Wyatt Sr. purchased his land from I.E. Gates on November 13, 1903. Located on the south side of Fifth Avenue, between Fifteenth and Sixteenth Streets, this classical three-story Edwardian Georgian structure was designed by Edwin N. Alger, who had just completed the Frederick Hotel in Huntington. The home has a central entrance hall; to the left is the living room and dining room that share a fluted column verandah and terrace. Brackets extend from the front eave and entrance; a spindled balustrade is used for ornamentation.

M.N. OFFUTT HOME, ARCHITECT EDWIN N. ALGER, BUILT 1910. Located next door to the Wyatt home, this handsome three-story wood shingled and stucco home evokes the craftsman's style of the Edwardian age. The porch has squared columns and a balustrade, with brackets extending from under the roofline. The third-story straight wood timber trim is recessed in stucco; it terminates as a dentil block trim above the shingled second story.

THE FREDERICK HOTEL, BUILT 1906, ARCHITECTS EDWIN N. ALGER AND J.B. STEWART.
Edwin N. Alger, one of the best known architects in West Virginia, arrived in Huntington in July 1901 on a special mission with local architect James B. Stewart, who had completed the supervision work of the Cabell County Courthouse in 1900. Alger's first architectural position was the complete design of the Carnegie Library, built in 1902. Alger's Edwardian Renaissance Frederick Hotel, built by the Central Realty Company of Huntington, would be one of West Virginia's great architectural achievements. It required over 3.7 million bricks and over 10,000 cubic feet of stone for trim on the Fourth Avenue and the Tenth Street sides. The lobby is 61 feet wide, 33 feet deep, and 42 feet high; to the center of the dome above is a stained glass window. The exterior brick was purchased from Portsmouth, Ohio. The stone throughout the building also came from Portsmouth, and was cut, erected, and put in place by P. Henson of Huntington. The marble work on the interior was furnished and erected by the Buckeye Marble Works of Cincinnati, Ohio. The Ceramic-Mosaic Tile Company of Zanesville, Ohio, put in the impressive tile flooring and wainscoting. (Photographs courtesy of Randal Brown Collection.)

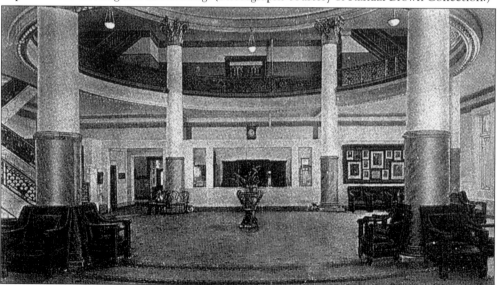

J.W. VALENTINE BUILDING, ARCHITECT SIDNEY LOGAN DAY, BUILT 1908. Located at 1007 Fourth Avenue and Tenth Street in downtown Huntington, the original J.W Valentine building would later become the Day and Night Bank. The Valentine building was one of the first terra cotta cream tile buildings to be built in Huntington. Frank L. Whitaker, owner of the 350-acre Whitaker Estate, was the president and founder of the first state bank in Huntington. Later the bank was consolidated with the Huntington National Bank. (Courtesy of Randal Brown Collection.)

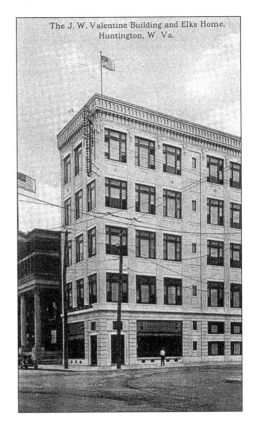

The J. W. Valentine Building and Elks Home, Huntington, W. Va.

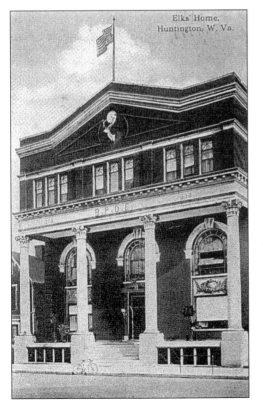

Elks' Home, Huntington, W. Va.

HUNTINGTON LODGE OF ELKS, NO. 313, BUILT 1910. On the evening of January 28, 1910, a grand opening and ball announced the opening of the Huntington Lodge of Elks No. 313; over 1,200 people attended the delightful reception. It was just nine years before that William Selber first introduced the proposition of the new building. Over the years certain architectural changes have been made to the front edifice. The elk projecting from the top center roundel no longer exists. (Courtesy Randal Brown Collection.)

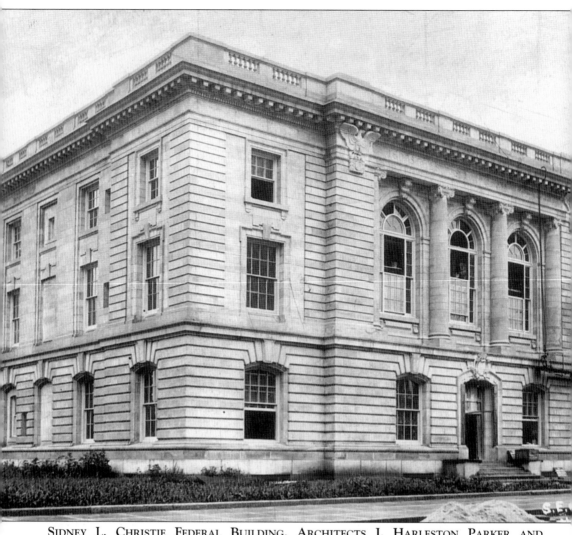

SIDNEY L. CHRISTIE FEDERAL BUILDING, ARCHITECTS J. HARLESTON PARKER AND DOUGLAS H. THOMAS JR. This three-story building, also known as the Sidney L. Christie Federal Building, was constructed from 1905–1910. The federal building still houses the federal courtroom and offices but is no longer used as a postal facility. The building was renamed in 1974 for Judge Sidney L. Christie, a prominent regional figure in the 1920s and 1930s who served as district judge in Huntington from 1964 until his death in 1973. The building's design was awarded in 1903 to the firm of Parker & Thomas of the cities of Boston and Baltimore. The steel frame building is designed in the Second Renaissance Revival style and is clad with Bedford Indiana limestone on the exterior with granite water table. The formal façade composition relies on the unity of parts, scale, symmetry, rhythm, and classical ornamentation for its architectural effect.

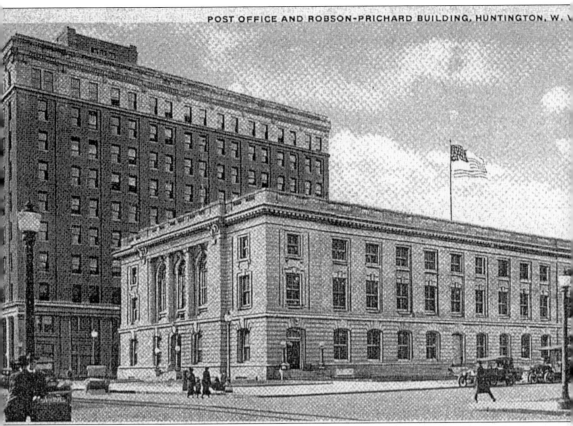

FEDERAL BUILDING, POST OFFICE, AND ROBSON-PRICHARD BUILDING. By the 1890s, there was a pressing need for a permanent Federal building to replace the rental space used by Federal agencies in the city. A strategic location on Ninth Street was chosen, as it was a major transportation corridor. On June 19, 1903, the site was purchased by the United States from a private citizen, B.W. Foster, for $13,536.06. The firm of Parker & Thomas was selected from nine entries to design the building. Partners J. Harleston Parker and Douglas H. Thomas Jr. maintained two offices, in Boston and Baltimore. Both were classically trained architects who studied at the Ecole des Beaux Arts in Paris. The plans and specifications were approved by the Treasury Department in September 1904. The construction contract was awarded to William Weber of Texas for $112,850 in December 1904. The construction of the building had several complications. Weber committed suicide and the site superintendent, John Bright, died of natural caused in January 1907. However, the building was largely completed by January 1907 when the postal department moved into the new facility. The total cost of construction, including the land, was $126,386.03. The building soon proved to be too small. By 1910, the population of Huntington had grown nearly threefold. Two additions were made to the federal building. The 1915–1917 addition by James A. Whitmore provided more space for the postal areas and courtroom offices on the western end of the building. The actual construction period ranged from November 1916 to December 1918, and was completed by March 1919 for a total cost of $207,903.89, including the cost for the land. The second and final addition occurred in 1935–1937. Land was purchased along Fifth Avenue for $156,000 in 1931. Huntington architect Robert I. Willet, with the firm of Meanor & Handloser, Associates, prepared the drawings. Louis A. Simon, supervising architect of the Treasury Department, approved the drawings in October 1935. By late 1937, the addition was completed. (Courtesy of Randal Brown Collection.)

ROBSON-PRICHARD BUILDING, BUILT 1910–1911, ARCHITECTS ELZNER & ANDERSON. The former Robson-Prichard Building is located on the central block of Ninth Street between Fifth and Sixth Avenues. The Robson Prichard Investment Company chose the Architectural firm of Elzner & Anderson of Cincinnati, Ohio, to design the building. Fred C. Prichard and Hugh A. Robson maintained entire floors for their offices until 1929. In 1941 Guaranty Bank and Trust occupied the first floor and eventually gained control of the building and renamed it the Guaranty Bank Building. In the late 1990s John Hankins purchased the building. His restoration associates began restoring the historic edifice. The main entrance above has a pair of five-sided brick columns resting on a rusticated stone. Above the main entrance are three ornate cartouches with garland that have been gold leafed. John Hankins placed a pair of French street lights that once graced the plaza of the Louvre Museum in Paris.

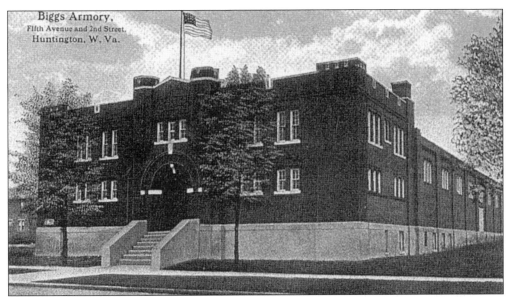

BIGGS ARMORY, 1912. In 1875, George N. Biggs and his brother-in-law Dr. A.J. Beardsley operated one of the largest mills in West Virginia. The vast mill was once located on the south side of Fourth Avenue where the Keith Albee Theater stands today. In 1912 Col. George Seldon Wallace made a contract with Biggs under the terms of which Biggs agreed to furnish a lot fronting Fifth Avenue on the south side between First and Second Streets East and $18,000 to be used in construction of an armory. Biggs rented the premise to the State of West Virginia for $2,500 per year and at the end of the 10-year period the state had the right to purchase the lot and the building at the price of $25,000. In 1921 the State purchased the property for $33,000 from the Biggs family. (Courtesy of Randal Brown Collection.)

FIFTH AVENUE HOTEL, BUILT 1910, BY HANSFORD WATTS. Located at 901 Fifth Avenue, this hotel was built by Hans Watts who had purchased half of a city block from the Schneider family. The original First Congregational Church once stood on this corner. The former Fifth Avenue Hotel is one of Huntington's exceptional Edwardian buildings; its exterior edifice is a harmonious blend of ornamented brick work of cornices, pilasters, and dentil block trim. Hans Watts was born in Wayne County on February 4, 1873. In 1896 he came to Huntington and, with Walter Davis, opened the Adephi Hotel. Later he opened the Hans Watts Jewelry Store on Third Avenue and Tenth Street.

FORMER VINSON & THOMPSON BUILDING, BUILT 1910, ARCHITECT EDWIN N. ALGER. Located on the west side of Ninth Street between Third and Fourth Avenues was the Vinson & Thompson Office Building. The front entrance has a stone edifice, with Edwardian ornamented bricks rising five stories to an ornate cornice with arched windows and stone garland caps. The Vinson & Thompson Building was home to the Vinson Thompson Meek Scheer law firm, and offices for the first interurban rail service between Huntington and Ashland, Kentucky. Zachery Taylor Vinson served on the board of directors of the United States Coal and Oil Board. The Vinson & Thompson building suffered damage from the 1913 flood and the 1937 flood. In May of 1937 the wealthy former mayor of Huntingon, Douglas C. Tomkies, purchased the building from the Columbus Mutual Life Insurance Company for $30,000. He referred to the building as "Urban Rubble" rather than urban renewal. His family owned Tomkies Department Store in Hinton, West Virginia. The building was razed in 1976.

CHESAPEAKE & OHIO STATION, HUNTINGTON, BUILT 1913. The C&O Station is the largest of nine classical revival style stations constructed by the railway company, a CSX predecessor between 1905 and 1936. The impressive three-story façade has a central temple form entablature housing a roundel leaded glass window. An elaborate banding of dentil block brackets defines the entablature. The massive gable rests upon four three-story fluted Ionic columns. The main entrance has a Palladian arch with white Ionic columns. Above is a balcony with three windows with a carved stone garland. The first floor arch entrance is balanced by a series of windows with fanlight mullions and stone bracket.

MASONIC TEMPLE AND RIVER TOWER, BUILT 1913, ARCHITECT WILBUR T. MILLS. Located on the northeast corner of Third Avenue and Eleventh Street, the seven-story structure was originally known as the Masonic Temple and Watts & Ritter Wholesale Dry-goods Company. The Watts & Ritter Company occupied the building from 1914 until the firm's closing in 1959. Additions include a five-story annex in 1922 and two additional stories in 1926, which completed the seven-story block. The main entrance above has two one-story glazed terra-cotta columns flanking each side. These Roman fluted columns have ornate belted globes as capitals. Above is a massive cartouche of Roman laurel leaves framing a stained glass symbol of the Masonic Order.

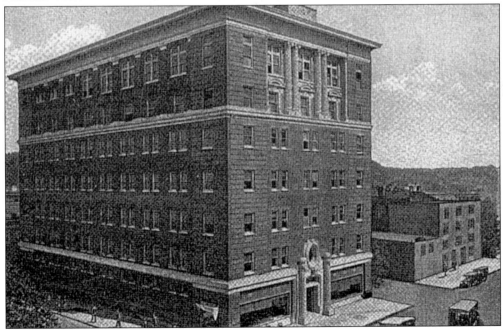

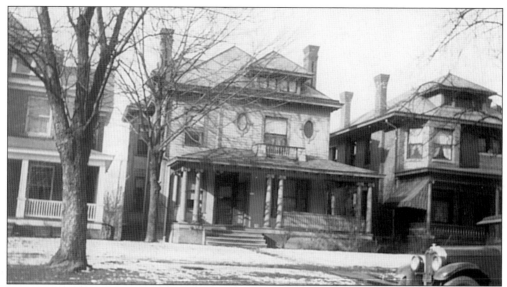

E.G. ANDERSON HOME. Once located at 528 Fifth Avenue was the E. G. Anderson home; this two and a half–story Queen Anne structure had a slate roof. The Anderson family became involved in the department store business. In 1902 John W. Valentine and W.H. Newcomb opened a department store on the south side of Third Avenue between Ninth and Tenth Streets. In 1907 Valentine sold his interest to G.H. Anderson of Portsmouth, Ohio, and the famous department store became known as Anderson & Newcomb Department Store.

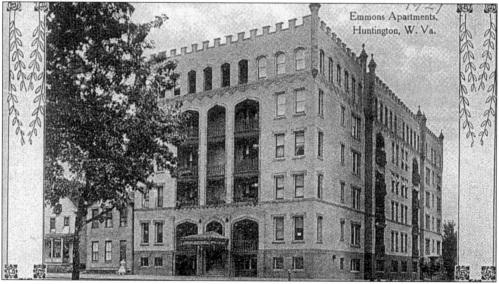

EMMONS APARTMENTS. Arthur Emmons Sr. along with architect J.B. Stewart planned an elegant residential apartment complex for Twelfth Street and Third Avenue in downtown Huntington. Stewart passed away in 1908 and Edwin N. Alger assumed the responsibility of completing the design and overseeing the construction in 1910–1911. The complex has 31 apartments and has served a prominent clientele for many years. In 1924 Arthur Emmons Jr. commissioned the architectural firm of Meanor & Handloser to build a new addition of 61 apartments connecting to the older structure at 1207 Third Avenue. Frank P. Hines and his son Charles Hines were the contractor builders. (Courtesy of Randal Brown Collection.)

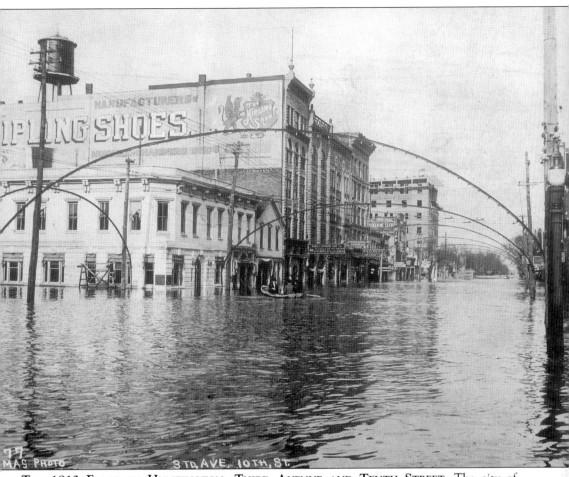

THE 1913 FLOOD IN HUNTINGTON, THIRD AVENUE AND TENTH STREET. The city of Huntington experienced a devastating flood in 1913. This rare photograph was taken on March 30, 1913, by Thomas Studios. The view is from the intersection of Third Avenue and Tenth Street, looking east toward Eleventh Street. The Masonic Temple was still under construction. Today Love Hardware and Mack & Dave's occupies the city block on the north side of Third Avenue. Third Avenue beyond Twelfth Street in 1913 was still a residential area. (Courtesy of WSAZ-Channel 3 and Homer Waugh.)

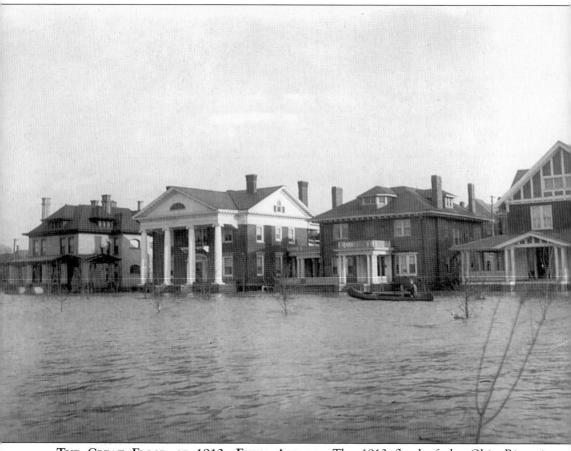

THE GREAT FLOOD OF 1913, FIFTH AVENUE. The 1913 flood of the Ohio River in Huntington had a profound effect on the city. Fifth Avenue had become the posh residential section of the city in the early 1900s. The flood extended south to Fifth Avenue, filling the basements of the homes and resting at the front doors of these historical Edwardian structures. Above is a photograph of the 1400 block of Fifth Avenue, between Fourteenth and Fifteenth Streets. From left to right are the former Biggs home on the corner of Fifteenth Street, designed by architect Edwin N. Alger; the former Zachery Taylor Vinson mansion, designed by architect H. Rus Warne; the former Charles Russell Wyatt home, designed by architect Edwin N. Alger; and M.N. Offutt's Arts and Crafts home, also designed by Edwin N. Alger.

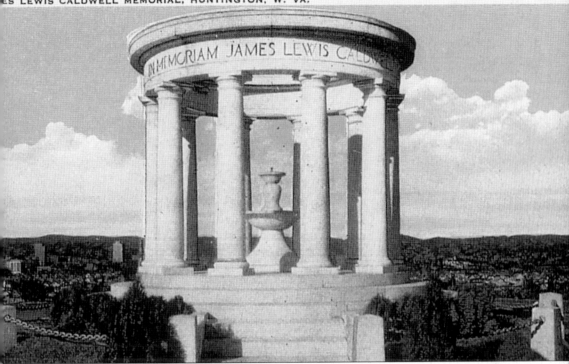

RITTER PARK, HUNTINGTON. The City of Huntington purchased some property on the city's south side in 1908 to create a park. Charles Lloyd Ritter had been the catalyst that would trigger the change of a small railroad town into a promising and stable city. Ritter had purchased large tracts of land on the southern hills of the city for its valuable timber; however he remained interested in real estate. Ritter's donation of additional land would forever change the concept of using the area for a public incinerator and a dumping area for landfill. Many of the early landowners on Thirteenth Avenue recall cornfields and vegetables gardens where the park is today. The official opening of Ritter Park was September 11, 1913, and this marked the beginning of Huntington's most desirable suburb. It was not until after World War I that the park finally started taking on its own identity. The area where McCoy Road begins became the Rose Garden, south of Four Pole Creek. The park exhibits the work of Gus Wofford, a landscape architect hired by the Board of Parks Commissioners in the 1920s. Wofford worked with stone and masonry experts Samuel and Evan Sadler to design the Rose Garden and create a refined setting for some of Huntington's finest architectural residences. On November 26, 1928, L.D. Beuhring and his wife Nannie conveyed parcels of land for $1 to the City of Huntington for the creation of Memorial Park. On May 23, 1930, the City of Huntington granted, deeded, and conveyed over the land to the Board of Park Commissioners, for the creation of Memorial Park by Mayor J. Boyce Taylor in 1930. Prior to the creation of the Ritter Park Commission in 1926, the only accomplishments that existed other than the Rose Garden at that time was on Gobblers Knob or Caldwell Point. The Caldwell family would build as a gift to the park and the City of Huntington a Greek style temple of ten Ionic marble columns in a circular structure with a central marble water fountain. This temple pavilion was in memory of James Lewis Caldwell. This elegant pavilion would fall victim to the hands of vandals and considerable destruction. By 1945 Caldwell's daughter Ouida (Mrs. Charles Wellington Watts) made persistent efforts for funding for restoration. Finally, she asked the Park Board of Commissioners for the removal of the marble and stone pavilion, asserting the monument was falling victim to possible political posturing and unquestionable neglect.

WHITAKER ESTATE AND RITTER PARK. Jasper Samuel Sadler, the son of Charles and Nancy Sadler, was born in Halifax County, North Carolina on October 20, 1871. Jasper and his brother Jessie came to Huntington in 1897; after arriving Samuel became a supervisor on a brick and masonry job for Frank L. Whitaker, who had just purchased a 350-acre estate extending from Fifth Street West to Fifth Street East. The one-mile area and mountain became known as Whitaker Hill. Frank L. Whitaker wanted to create a park-like appearance for his vast Adirondack cabin. During the construction of the stonewalls that surround the former Whitaker Estate, Samuel had the pleasure of meeting Minnie Cox, who had just moved to Huntington with her family from McGoffin County, Kentucky. Jasper and Minnie soon married. Their first home was this log cabin sitting on the top of Whitaker hill. Their first child, Jasper Evan Sadler, was born there. The Sadler family remained busy working with Frank L. Whitaker and his grand plans for his 350-acre estate. Minnie, while caring for her son Evan, had the great misfortune of carrying the only water source, which was at the foot of the hill. According to family legend, Minnie told Samuel that she was leaving him, not for lack of love, but because of the backbreaking water situation. Some years later Frank L. Whitaker allowed the Boys Scouts of America to use the cabin as a retreat. The Sadler brick and masonry business did well in the early 1900s and Samuel bought three acres above what is now Ritter Park on Hawthorne Way, where they built several impressive homes.

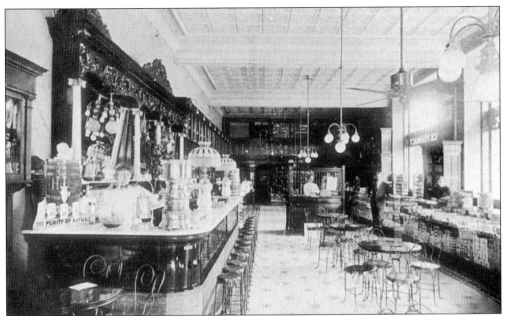

HUNTINGTON. The closing days of Huntington's Edwardian age were blessed with many creature comforts. The Frederick Hotel Pharmacy boasted a posh soda fountain and ice cream parlor. Heiners Bakery was still making daily delivery of their fresh bread and pastries to the community. There was peace and serenity in the Jewel City; however all this was to change. The great flood of 1913 left an indelible mark upon the city and its citizens. Global problems were beginning to approach our own front door. From 1914 to 1918 World War I once again turned Huntington into a major shipping port. (Courtesy of WSAZ Channel 3 and The Randal Brown Collection.)

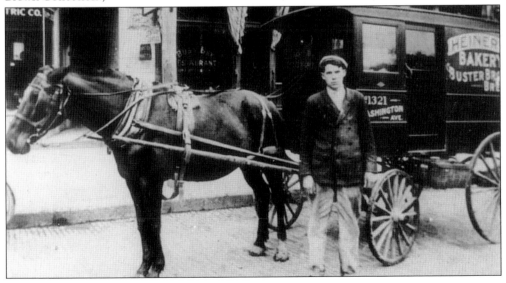

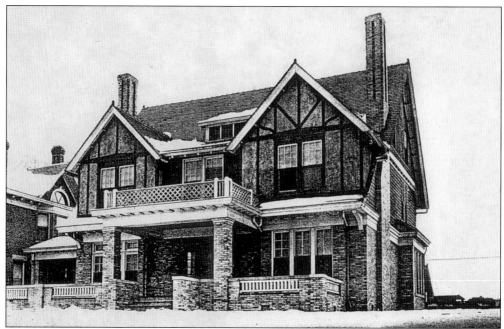

J.E. AND CARRIE THOMPSON HOME, BUILT 1909–1910, ARCHITECT EDWIN N. ALGER.
Located on the south side of Fifth Avenue between Sixth and Seventh Streets stands the former Thompson home. The Thompson family were the principle stockholders in the Consumer Power & Light Company, which later became the Consolidated Light & Heat Power Company. Upon the death of Carrie V. Thompson (below, left) it was stipulated in her will that the vast home be donated to the YWCA. The home is an extraordinary example of the Arts & Crafts style of architecture, with its tile roof and large gables supporting ornate chimneys. The exceptional central staircase is pictured below to the right.

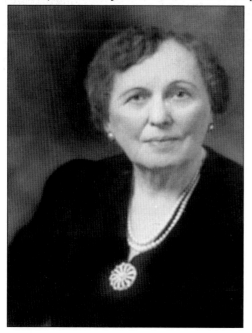

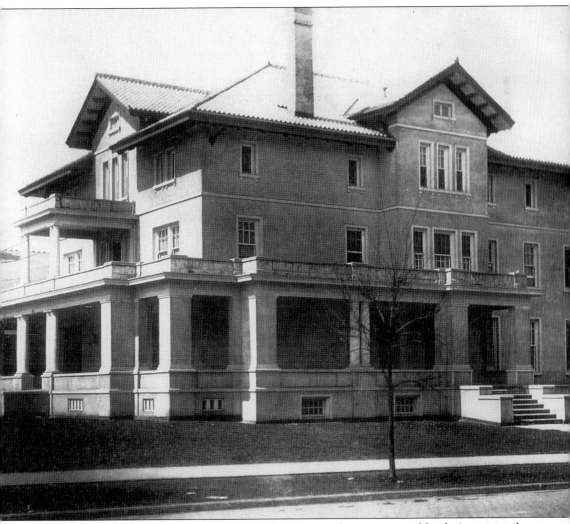

C. PAUL NELSON HOME, BUILT 1918. Located on the northwest corner of Sixth Avenue and Thirteenth Street, the Nelson home was eventually converted into a hospital. The mansion was completed in 1918 by Mr. and Mrs. C. Paul Nelson; it was one of Huntington's largest homes. This imposing Italian Tuscany villa has 11,500 square feet of space and featured the city's first indoor swimming pool. A ballroom was located on the third floor and dumbwaiter service was available to all four floors from the kitchen. It remained in the Nelson family until 1948 when it was sold to Dr. Arthur Jones and became the Huntington Orthopedic Hospital.

FORMER BILTMORE HOTEL, ARCHITECTS MEANOR AND HANDLOSER, BUILT 1919–1920. The Biltmore Hotel of Huntington was one of the few and rare examples of the Beaux-Arts, French Academic architecture of the 19th century. The front sandstone façade was one of the finest examples in the city of Huntington. In its early days the hotel served the community well with its old world charm, up until the Great Depression. Following the return of the soldiers from World War II the quaint hotel ambiance gave way to the demands of young men returning home. Courtesans and ladies of the evening prevailed their talents and services to men of means, a social conduct not tolerated at the more posh hotels in Huntington. The Biltmore Hotel was demolished in 1999 for parking facilities for the new Jean Dean Public Safety Building.

THE STANARD BUILDING/THE JEAN DEAN PUBLIC SAFETY BUILDING, BUILT 1919–1920, ARCHITECTS MEANOR AND HANDLOSER. In 1998 the city council passed a resolution in support of the Huntington Municipal Development Authority to proceed with the renovation of the Stanard Building as the new Jean Dean Public Safety Building and the new home of the Huntington Police Department. This nearly $4 million renovation added a new luster to one of Huntington's first contemporary commercial buildings in the Bauhaus style, a school of architecture that existed from 1919 to 1933.